Wicked Women
of OHIO

Wicked Women of OHIO

JANE ANN TURZILLO

THE
History
PRESS

Published by The History Press
Charleston, SC
www.historypress.com

Front cover, clockwise from top left: public domain; Cleveland State University Library; Mike Tailford; Library of Congress; *Washington Evening Star*, Washingtoniana Division, D.C. Public Library; Mike Tailford; public domain; Vinton County Historical Society & Genealogical Society; public domain.
Back cover, top: Ohio History Connection; *bottom left*: Ohio History Connection; *bottom right*: public domain.

First published 2018

Manufactured in the United States

ISBN 9781467138260

Library of Congress Control Number: 2018942436

For my sister, Mary Turzillo.
A hard act to follow.

CONTENTS

ACKNOWLEDGEMENTS

Research for this book took me from California to Arizona to the Royal Library of Scotland with many stops in between. I was delighted with the people I met and the information and photographs they shared with me. I could not have written this book without all of those people. I owe them all my gratitude.

Before I thank all the wonderful librarians, record clerks, volunteers, authors, attorneys, friends and family, I want to thank my commissioning editor, John Rodrigue. He was always there when I had questions or needed a sounding board. Without him, this book would not have seen print.

This is the seventh book that Marilyn Seguin, my good friend and fellow author, has read for me and tirelessly corrected my spelling, typos, punctuation and other faux pas. Thank you!

Thank you to Debra Lape, who helped me tell the story of her great-great-grandmother Lizzie. Many thanks to Mike Tailford, who gave me a look inside the life of his mother, Lillian Tailford. Thank you to Valerie Collins, who shared photos and stories of her grandmother Sheriff Maude Collins. All three were extremely generous with family stories and photos.

This book would not have come together without the research help of Ashtabula attorney Richard Dana; Ashtabula County public librarian Debra Laveck; Dan Hearlihy, Johnson's Island Preservation Society; author Robert Sberna; and my writing buddy, Wendy Koile, who is always ready for some field research.

Deanna L. Tribe, Vinton County Historical Society president, and Lawrence McWhorter, Vinton County Historical Society past president and Clinton Township trustee, lent me photos and took a whole day to show me around Vinton County and helped make Sheriff Maude's world come to life.

I am indebted to the following librarians, archivists, records custodians, historians, authors and experts. Each and every one played an important part in helping me find the facts and photos. Lily Birkhimer, digital projects coordinator, Ohio History Connection; Liz Plummer, and all Ohio History Connection librarians; Adam Jaenke and Brian Meggitt, Photograph Collection, Cleveland Public Library; Nora, Librarian Chat Service, New York Public Library; National Library of Scotland; Jill Gregg Clever, manager, Local History and Genealogy Department, Toledo Lucas County Public Library; Donna Christian, Toledo Lucas County Public Library; Peggy Debien, Ottawa County Museum; Nancy Horlacher, Dayton Metro Library; Mary Plazo, division manager, Akron-Summit County Public Library; Rebecca Larson-Troyer, Akron-Summit County Public Library; Hilda Lindner Knepp, interim Batavia branch manager, Clermont County Public Library; Lauren Martino, Washingtoniana Division, Washington, D.C. Public Library, Special Collections; Catherine Amoroso Leslie, PhD, professor and graduate studies coordinator, the Fashion School, Kent State University; Jeffrey A. Huth Esq.; author Carl Feather; author Casimir "Ki" Jadwisiak; Jody Coleman and Chris Hatem, Vinton County Clerk of Courts; Jackie Ludle, Summit County Clerk's Office; Gary Puckett, prison records, Ohio Reformatory for Women; Joe Lancaster, volunteer, Greenbriar Historical Society; Gale Young, Vinton County Historical Society volunteer; Chuck Ocheltree, West Virginia Historical Society; Diane Mallstrom, Public Library of Cincinnati and Hamilton County; Julie Callahan, Columbus Metropolitan Library; Jason Wood; John Pointer; Phoebe Borman and photographer Debbie Gibson.

Those of us who write about history owe a debt of gratitude to the period journalists who covered the stories that we write about today. Sadly, their bylines never appeared at the top of their stories.

Love and thanks to my family—John-Paul, Nicholas and Nathan Paxton—and also to my new companion, Wyatt Earp, who lies under my desk while I write.

INTRODUCTION

The seed for this book was planted when I ran across a historic photo of a beautiful young woman wearing an Annie Oakley–style straw hat and a frock coat with a ruffled shirtwaist. I was immediately struck by the intelligence in her eyes, the confidence in her expression and a touch of haughtiness in the tilt of her chin. I had to know who she was.

It took several keystrokes on the computer to learn her name was Maude Collins, and she was the first female sheriff of Ohio. No wonder she looked confident! She led me to Vinton County and out on a single-lane gravel road where a double murder was committed ninety years ago. She solved those murders by reading footprints in the mud. When I read about the crime, I knew I had to write about Maude and how she brought Inez Palmer and Arthur Stout to justice for killing Stout's father and stepmother.

While Inez may have been wicked, other women in this book—like Maude—were not, and they deserve to have their stories told.

Four madams are included in this book. Without passing judgment, I have tried to present what their lives were like. These women all had something more in common than the sex trade: They were tough as nails and successful businesswomen.

Clara Palmer contended with constant police raids in the 1880s and '90s. Only her death could shut the doors of her gilt-edged bordello in Cleveland.

You could say that Lizzie Lape had a franchise on bawdy houses in Ohio from the 1870s to 1904, having opened them from Akron to Marion to Lima and beyond. She married a number of husbands along the way, too.

Rosie Pasco and Lillian "Ginger" Pasco Tailford hailed from Ottawa County. Their houses were legend, as were their soft hearts and philanthropy. Rosie opened her doors in the 1930s. Ginger's house was closed down by the feds in 1970.

Mildred Gillars is the lone traitor in the book. As a failed actress, she left the United States to find work in Europe before World War II. Because she fell in love with the wrong man, she wound up promoting Nazi propaganda as "Axis Sally" on the radio.

And then we have the killers.

Hester Foster was already doing time at the Ohio State Penitentiary when she lost her temper with another female inmate and bashed her head in with a shovel. Foster was the first woman in Ohio to be executed. She was hanged in 1844.

Cincinnati's "Big Liz" Carter would have met the same end for poisoning her man in 1890 if it had not been for her size. She escaped the noose because of her weight.

Love of a married man drove Jean Maude Lowther to murder in 1930. She hid in the bushes on a rainy night at a lonely spot near Ashtabula and waited for her lover to drive his unsuspecting wife into an ambush.

Dovie Dean was after Hawkins Dean's 115-acre farm in Clermont County when she married him in 1952. She used arsenic to kill him. During her trial, she became known nationally as "the woman who couldn't cry." She was the second woman to die in Ohio's electric chair.

After Martha Wise's abusive husband died, she took up with a new man. But her family disapproved and forced her to end the affair. In 1925, she retaliated by slipping rat poison into the Medina County family's drinking water. Sixteen family members died.

By far the most evil woman in the book is Anna Marie Hahn. In 1937, she dosed at least five elderly Cincinnati men with arsenic and croton oil then watched them die in agony while she pretended to be caring for them. Her motive was money. A sixth victim lived to testify against her. She was the first woman to die in Ohio's electric chair.

You might say Maude Collins brought all these women to my attention, and in doing so gave me the opportunity to research their stories and write about them. I hope you enjoy reading about these women and their crimes as much as I enjoyed researching and writing about them.

DOUBLE MURDER
AT AXTEL RIDGE

Inez Palmer (1926–27)

Inez Palmer and Arthur Stout shocked the small Vinton County community when they murdered Arthur's stepmother and tried to burn the evidence, then killed his father and stuffed the body down the well. The lovers might have gotten away with it had it not been for Sheriff Maude Collins.

Maude was sworn in as sheriff of Vinton County in October 1925, just two days after her husband, Sheriff Fletcher Collins, was gunned down while serving a warrant during a traffic stop on the Coalton Pike half a mile north of Jackson. Until her husband's death, the thirty-two-year-old mother of five children, ages three to eleven, had been the jail matron. When the coroner, who lawfully would have succeeded Fletcher Collins, refused the office, the county commissioners appointed Maude as head law enforcement officer. She put on the badge, took up a gun and became the first female sheriff in Ohio history.

Maude's most shocking case began in the spring of 1926 after Arthur, thirty-three, brought Inez, nineteen, from Moundsville, West Virginia, to Vinton County to live with him and his two boys a few miles outside of Dundas. Newspapers of the time reported her age as twenty-four, but census, prison and orphanage records show that she was born on December 4, 1907. Supposedly, Inez was hired to keep house, since Arthur's wife, Amelia, died. The two took up residence down a one-lane dusty road in a small cabin on Axtel Ridge on the rolling farmland owned by William Bray "Bill" Stout, Arthur's father. Because they lived "without benefit of

clergy," and maybe because Inez was actually much younger, countryside tongues began to wag.

Bill Stout was a sixty-five-year-old father of three grown sons. He was a respected, well-to-do farmer who had lost his first wife, Almira, sometime after she appeared in the 1900 census and before 1906, when he married Sarah Pearce. Sarah was a God-fearing woman, mindful of the family's morals and reputation. The illicit "love nest" a couple miles down the road upset her to no end, and she let her stepson Arthur know it. He paid her no heed, so she went to the justice of the peace and had Arthur arrested in mid-November for "living in an illicit relationship." Bill, being less rigid than his wife, hired a lawyer for his son and bailed him out of jail.

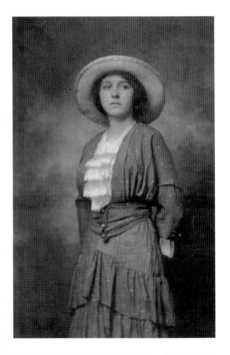

Maude Collins, Ohio's first female sheriff. *Courtesy of the Vinton County Historical Society & Genealogical Society.*

A few days after Arthur got out of jail, Sarah's badly beaten body was discovered by a neighbor boy. Gertrude Perry sent her fourteen-year-old son, Manville, on an errand to Bill Stout's house, possibly to borrow sugar. When Sarah did not answer the boy's knock at the kitchen door, he went to the sitting room door, which stood open a crack. He was confronted by a grisly scene when he peered inside. Sarah Stout was sprawled facedown on the floor in front of the stove, her hair matted in blood, according to the newspapers. A horrible smell of something burning hit him in the face.

Manville ran to find his father, William Perry, and Wesley Christian where they were working at the hillside coal mine. Perry called the sheriff's office; Christian went to find Bill Stout.

By the time "Sheriff Maude" (as folks called her) got the call, it was toward evening. She and her chief deputy, Ray Cox, went out to the Stout farm. It was dark when they arrived, but Maude could see that Sarah had been severely beaten then doused in kerosene and set afire. The flames had burned Sarah's clothing but had died out either for lack of air or because the flooring was not flammable. It was obvious the fire was meant to destroy the

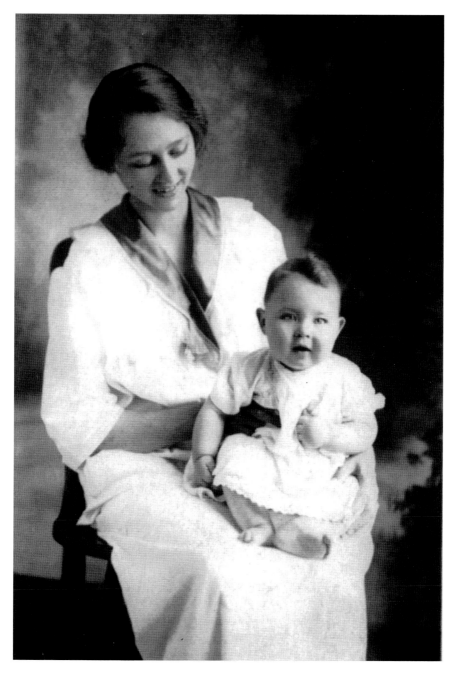

After her husband's death, Maude Collins was left with five children to support. *Courtesy of the Vinton County Historical Society & Genealogical Society.*

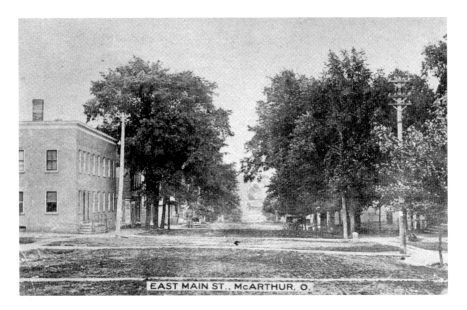

East Main Street, McArthur, Ohio. *Courtesy of the Vinton County Historical Society & Genealogical Society.*

evidence. During an autopsy, coroner Walter Swain found that Sarah had been choked to death.

Maude asked the neighbors if they had seen any strangers around the farm. No one had. Deputy Cox walked around the outside of the house looking for anything suspicious. Nothing turned up.

Bill Stout sat on the steps of the house, weeping. He told Maude that Sarah had packed him a lunch early that morning. After that, he left the house to work in the north field, and he had not seen anyone around the house. Arthur later corroborated that alibi. He had seen his father in the field.

Maude tentatively marked Bill off the suspect list, but Arthur rose to the top of her list. There are a couple of different stories as to how Maude investigated the murder and wound up arresting Arthur. One version claims that Sarah told her neighbor Lucy Gibbs that she was frightened that Arthur would kill her because she caused him to be arrested. Gibbs's name appears on the trial witness list. Perhaps she was going to testify to Sarah's fear.

Another version was written by an unknown author and reprinted in a July 1992 article, "Twin Horror of Axtel Ridge," in *True Detective*, a magazine published in the UK. It purports to be an interview with Sheriff Maude Collins at the time, in which she tells of calling in tracking dogs from Pomeroy forty miles south along the Ohio River.

Before the dogs got there, Maude asked Arthur for an accounting of his time. He claimed to have chopped wood most of the day. Later in the afternoon, he used his horse to drag a wagon tongue he had borrowed from his father back to the older man's farm. She asked him if he had gone in the house. "You didn't even drop in to pass the time of day with your stepmother?"

Arthur's answer was awkward. "No, we haven't been on speaking terms for some time. I guess you know why."

After the tracking dogs arrived, the sheriff set them to work. They sniffed the path Arthur took with the horse and wagon tongue from his cabin right up to Bill and Sarah's kitchen door. Presented with the dogs' finding, Arthur admitted going to the kitchen door but swore he never entered the house.

Sheriff Maude gave the evidence some thought and decided it all pointed toward Arthur. She and her deputy went to prosecutor John E. Blake and asked him to get a warrant from Justice of the Peace George W. Specht. Within a short period of time, the sheriff and deputy had their warrant and went back out to Axtel Ridge to arrest Arthur for the murder of his stepmother. As they were taking him away, Inez Palmer rushed out the door to give him an ardent kiss on the lips. Apparently, it was the first time Maude ever laid eyes on the pretty, dark-haired "housekeeper."

Bill Stout was astounded at his son's arrest. "I can't believe Arthur did it, but if he did, I want him punished."

A newly minted attorney named William J. Jones took over as prosecutor of the case. After graduating from The Ohio State law school the previous June, he decided to go to McArthur to gain experience. Little did he know that the experience would include a scandalous murder case.

Jones wanted Arthur held until the next session of the grand jury convened in January. Arthur was lodged in the county jail. Jones denied him visitors, perhaps because the jail was in the sheriff's home. Inez disregarded the rules and made her way six miles through the cold at least once a week to see her lover. Sheriff Maude caught her talking to him through the window many times and sent her off.

On February 17, 1927, the grand jury indicted Arthur for the first-degree murder of Sarah Pearce Stout.

Sometime during that winter, Bill moved into Arthur's cabin with Inez and his two grandsons, William H., nine, and Arthur Jr., thirteen.

And then Bill came up missing. On Thursday, March 10, Maude received a phone call from a clerk at the general store in Oreton. Inez Palmer had asked the clerk to make the call. Bill Stout had "left the country. He said he

Axtel Ridge homes of the Stout family. *Courtesy of the Vinton County Historical Society & Genealogical Society.*

was going west and he wasn't coming back." This was problematic because the elder Stout was supposed to testify in Arthur's trial.

Suspicious, Maude and Deputy Cox went out to the cabin to talk to Inez. The young Palmer woman said she was worried because Bill had left the night before and threatened to never return. She claimed he had been out all day mending fences. Maude must have wondered why he would be outside mending fencing in the cold winter weather. She and Cox followed the fences until they found Bill's lunch bucket under a tree. Inside the bucket was a handwritten will, leaving both farms to Arthur. It struck Maude as strange for him to cut off his other two sons. "But maybe it was his way of making up for accusing Arthur," she said, apparently not believing it.

Cox remarked that the will would not be lawful, because it was not witnessed.

The two law enforcement officers began looking around at the ground and saw footprints in the cold mud. They were curious to see if they

belonged to Bill, so they went back to the cabin to get a pair of Bill's boots to see if they fit the prints. While there, they carefully went through the room where Bill had been staying. As best they could tell, none of the older man's clothing was gone. While searching, Maude laid eyes on a pad of the same paper as the will had been written on. She tucked the pad away to take back to the office.

They showed Inez the will. She seemed overjoyed and commented that it was as good as a confession. "Can Arthur come home now?" she asked.

A neighbor gave Maude and Cox a key to Bill's house. They carefully looked around to see if anything had been disturbed. They noted that wherever Bill had gone, he had not taken anything with him. He had even left his car behind. During their search, they looked for a sample of his handwriting but found none.

Back on the fence line, the boots fit the tracks perfectly. But "Sheriff Maude" noticed something peculiar. The print impressions that were supposedly Bill Stout's were not very deep. She determined that Cox was approximately the same height and weight as Bill Stout and compared Cox's prints to those in question. They were not equal in depth.

Maude slid Bill's boots onto her own feet and walked around. Then she compared her impressions with the ones supposedly left by Bill. Hers were almost equal in depth. She and Cox knew then that Bill had not made the footprints—either a woman or one of the boys had.

They took the handwritten will to the bank in McArthur where Bill Stout had an account and showed it to the manager. He confirmed what they already knew. It was forged. The will was a fake. Evidence was mounting. And they suspected that wherever Bill Stout went, he probably did not go voluntarily.

That evening, Maude got a visit from Bill's closest neighbor, Lettie Camp. According to an undated article at the Vinton County Historical Society, "The Axtel Ridge Murders," by an unknown author, Camp told Maude that Inez had a piano.

"You see, that Palmer woman used to bang away on her piano all the time." Camp said she could hear the music, as her house was on a slope that overlooked Arthur's cabin. "Soon after Bill Stout moved there she quit playing." One of the boys told her their grandfather made Inez stop because it was disrespectful to the memory of Sarah. "Well, about noon yesterday, I was in my kitchen getting lunch ready when I heard her again, playing and singing at the top of her voice." She figured Bill would put a stop to it when he came home. "But he hasn't come back, has he?"

The next day, Sheriff Maude and Deputy Cox were on the road to Arthur's cabin when they saw Arthur Jr. and young William carrying buckets of water. They stopped and asked the boys why they were carrying water. After all, they had their own deep well in back of the house. The boys told them Inez had said not to drink the water from their well.

Maude and her deputy must have looked at each other with the same thought. Inez had something to do with Bill's disappearance. They took her back to McArthur for questioning.

After Inez was installed in the same jail where her lover was held, Maude and her deputy went back out to the cabin with the county coroner, ropes and grappling hooks. Bill Stout's body was found in the well, caught on a ledge twenty feet underwater. The icy water had kept the body well preserved. Coroner L.H. Dye was able to tell that Bill had died from a blow to the back of the head.

The boys had been taken to the children's home. Maude tried to talk with them, but they would not tell her anything. Instead, they cried and wanted to see Inez.

Inez faced interrogation by Maude, Cox and Jones. Inez tried to claim Bill had confessed to her that he was the one who choked Sarah to death. After a while, she finally admitted that she hit Bill in the back of the head with a piece of wood as he sat in front of the fireplace. In fact, she used both hands to hit him three times with a heavy piece of wood. She claimed it was self-defense because he had made improper advances toward her; however, the authorities figured she killed him because he was due to testify against Arthur, and Inez wanted to protect her lover.

Inez was charged with first-degree murder. After questioning, she was returned to her cell, where she slept most of the next day. A few days later, she pleaded not guilty at her arraignment. She was not given bail.

When Arthur Jr. and young William finally talked, they said that Inez compelled them to help her dispose of their grandfather's body down the well. An article in the *Canton Repository* reported that she had held a gun on them, but that was the only reference to a firearm.

Arthur's trial for the first-degree murder of Sarah Stout began on March 22, 1927. Thirty-nine of seventy jurors were examined by prosecutor Jones and Athens defense attorney R.W. Finsterwald of Woolley and Rowland law firm during the voir dire (preliminary examination of jurors by the judge and counsel). Twelve men were seated. (All prospective female jurors were excused.) James W. Darby was on the bench. Jones established the manner of death with eight witnesses, including Sheriff Maude Collins, Deputy Ray

Inez stuffed William Stout's body down the well (*at right*). *Courtesy of the Vinton County Historical Society & Genealogical Society.*

Sheriff Maude Collins's home was also the jail. *Courtesy of the Vinton County Historical Society & Genealogical Society.*

Cox, Coroner Walter Swain, the autopsy surgeon Dr. O.S. Cox and four others who had seen the body.

Swain told the jury that Sarah had been choked to death and then the killer had attempted to burn her body by pouring petroleum over it and lighting it. Dr. Cox did the actual autopsy. Maude and Deputy Cox testified to the condition of the body when first investigated. Maude was not new to murder trials. After her husband was slain, she attended every day of the trial of his murderer, George Steele.

The prosecution called Inez to the stand on March 24. For two hours, she refused to answer any of Jones's questions and answered only the most mundane inquiries when the defense questioned her.

Next, Jones put thirteen-year-old Arthur Jr. on the stand. By this time, he and his brother were in the custody of their mother's sister Carrie Cox. What young Arthur told the jury was chilling. The boy accompanied Inez to his grandparents' farm on November 17, 1926. Once there, Inez asked Sarah if she could borrow a shotgun. When Sarah bent over to retrieve the gun from a closet, Inez smashed her in the back of the head with a heavy object. The boy stood by and watched while Inez jumped on his grandmother and choked her to death. When Sarah was dead, Inez insisted that young Arthur pour kerosene over the body and set it on fire. Young Arthur told the court that his father encouraged and planned the murder.

Lawrence Palmer, Inez's brother, told the court that shortly before Sarah Stout's murder, Arthur Stout offered him fifty dollars if he would kill the older Stouts and burn their house to cover the crime. His testimony, and that of Arthur Jr., bolstered prosecutor Jones's case that Arthur had been the mastermind of the murders and that he had induced Inez to kill Sarah.

Before the day closed, Arthur Stout took the stand on his own behalf. He emphatically denied any connection with the murders and blamed them on Inez. His denial fell on deaf ears. After three hours of deliberation, the jury found him not guilty of first-degree murder but guilty of second-degree murder. Judge Darby sentenced Arthur to life in prison.

Maude delivered him to the Ohio State Penitentiary. The *Portsmouth Daily Times* reported that Arthur Stout asserted his innocence upon arriving at the pen. "My little son told on the witness stand that Inez Palmer was the one who did the murder. I had nothing to do with it." The article said he smiled broadly as he entered the gates of the prison. "Time will prove that I am innocent." Arthur Stout died in prison on November 11, 1959. He was sixty-six.

There seem to be no records of what happened to Arthur Jr. for his part in Sarah's murder.

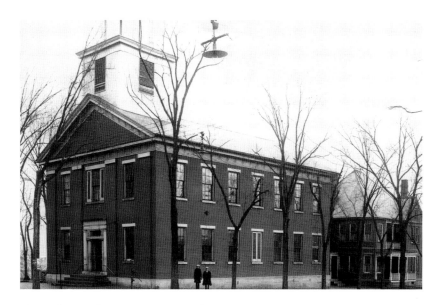

Vinton County Courthouse. The sheriff's house/jail can be seen behind the courthouse. *Courtesy of the Vinton County Historical Society & Genealogical Society.*

At sentencing, Inez asked for mercy. Before pronouncing sentence, Judge Darby questioned her about her background. She said that she had been raised in the Belmont Children's Home and been farmed out to several different families as a young child and in her early teens. The story was always the same. Time after time, the men in these homes pursued her, and so she would leave. She said Arthur Stout had promised to marry her.

Darby extended mercy, sentencing her "to be confined during her natural life, at work and labor, no part of which is to be in solitary confinement." Maude delivered her to the Women's Reformatory at Marysville on April 27, 1927.

That would have been the end of Inez's story, except that she made life at Marysville interesting for Redmond Norris, one of the male workers in the prison. In 1932, she used her charms and looks to snare favors such as silk undergarments and special privileges from him. The affair went on for more than a year and was made possible because Inez was a maid in Superintendent Louise Mittendorf's house. Inez and Norris took long automobile rides in the country under the guise of her teaching him to drive. One inmate said she had seen the two kiss. The butcher at the reformatory found them one time "scuffling around in Mittendorf's house, putting ice cream down each other's backs."

The affair not only disrupted Norris's marriage, but it also caused gossip and jealousy among a large number of the inmates. Other sexual activities among the women came to light, as well. The scandals brought Louise Mittendorf's tenure as superintendent of the reformatory to an end. She had been in that position since the facility opened in 1916.

Inez was not destined to spend her life behind bars. According to the *Athens Messenger*, Governor Martin L. Davey pardoned her two days before Christmas 1937. He did so at the urging of Marguerite Reilly, the Marysville Reformatory successor to Mittendorf, and William J. Jones, who had prosecuted Inez and Arthur Stout and was later a judge. "She was a mere child of 16 or 17 years, and I feel that her debt to society had been paid and therefore recommend for her a full pardon," Jones said.

Not much was known about Inez Bell Palmer before she showed up with Arthur Stout in Vinton County in 1926. When she was twelve, her father, John, turned her and her three brothers and three sisters over to the Belmont Children's Home after their mother, Rosellen, died on Christmas Day 1918. He did take the children back two years later.

Marysville women's warden Marguerite Reilly. *Courtesy of Ohio History Connection.*

Maude Collins (*standing*) became clerk of courts after her term as sheriff. *Courtesy of the Vinton County Historical Society & Genealogical Society.*

 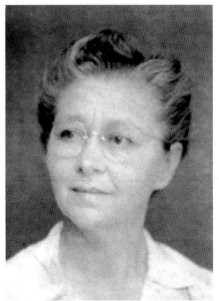

Left: Sheriff Fletcher Collins was gunned down while serving a warrant. *Courtesy of Valerie Collins.*

Right: Maude Collins in later years. *Courtesy of Valerie Collins.*

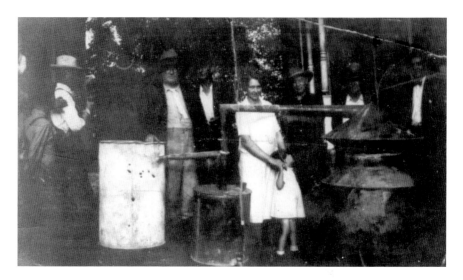

Sheriff Maude Collins with a still. *Courtesy of the Vinton County Historical Society & Genealogical Society.*

Inez married sometime after 1942. Her husband ran a restaurant in Martin's Ferry, Ohio. She died at the age of ninety-two in St. Clairsville, Ohio, at 3:45 a.m. on January 26, 2000. She was buried next to her husband at Mount Calvary Cemetery in Wheeling, West Virginia.

Blue-eyed Maude Collins was a direct descendant of the McCoys (of Hatfield and McCoy fame). At only five feet, six inches tall, she showed grit and bravery as she investigated and made arrests in five murders during her tenure as sheriff. She took Prohibition seriously and broke up at least one still in the woods of the county. She finished out a second term then ran for and was elected Vinton County clerk of courts. She remarried in 1940, but the union did not last. After she retired as a matron of the Columbus State School, she followed family members to California. Toward the end of her life, she returned to Columbus, where she died at Mount Carmel Hospital on June 8, 1972. She is buried alongside her murdered husband, Fletcher, in the Hamden Cemetery in Vinton County. She was seventy-eight.

LAUNCHED INTO ETERNITY

Hester Foster (1844)

The first woman to be executed in Ohio was a black woman named Hester (Ester) Foster. The year was 1844, and records are scant, so not much is known about her. We don't know how old she was or where she came from.

Foster was an inmate at the Columbus Penitentiary serving time for a long-forgotten misdeed. While incarcerated in the spring of 1843, she picked up a fire shovel and beat another inmate—a white woman whose name has been lost in time—to death. Another black woman whose name and fate are not known assisted Hester with the violence.

Hester was tried on December 22, 1843, at the Supreme Court of Franklin County. *The Exhibit of the Receipts and Expenditures of Franklin County for the Year Ending May 31, 1844* shows the county paid Perry and Goddard (presumably attorneys) $100 to defend her. The state later reimbursed Franklin County $1,700 for her case and that of William Clark.

Hester admitted her crime, but her lawyers argued that the killing was not premeditated, according to William T. Martin in *History of Franklin County*. On January 9, 1844, she was found guilty of first-degree murder. Judge Reed pronounced her sentence. It was death at the end of a rope.

The *Ohio Statesman* reported that "she exhibited very little emotion." When asked if she had anything to say as to why sentence should not be passed, she remarked that the other black woman had not received punishment. Hester's date with death was to be February 9, 1844.

OHIO PENITENTIARY, AT COLUMBUS, OHIO.

Early drawing of the Ohio Penitentiary at Columbus. *Courtesy of Ohio History Connection.*

While Hester awaited her sentence, she gorged on candy. She had sold her body to a surgeon for all the candy she could eat until her death.

Just a month before, a white male inmate—William Young Graham, a.k.a. Clark—was being tried for the murder of a prison guard. He was found guilty of slaying Cyrus Sells with a single blow of a cooper's axe. According to *A Historical Guidebook to Old Columbus: Finding the Past in the Present in Ohio's Capital City* by Bob Hunter, it was decided that the two would hang together because the crimes were similar, though not connected—and possibly to save money.

Just before 1:30 p.m. on Friday afternoon, February 9, 1844, Hester and William were escorted out from behind the penitentiary walls by Reverend Whitcomb and several clergy to a spot called Penitentiary Hill, where the gallows stood. Today, it is the location of the low ground at the corner of Mound and Scioto streets.

As the prisoners stood before the trap, Whitcomb offered a solemn "exhortation." The *Ohio State Journal* reported that Hester "seemed much affected, and knelt and prayed with the clergy with much fervor."

The editor estimated the crowd to be anywhere from twelve thousand to twenty thousand, a quarter of them women, "who were rushing eager to get a conspicuous position, so that they could gloat their eyes with the rare sight." He wrote that there was much noise, drunkenness and unruliness in

the crowd. A blacksmith lost his footing and was pushed to the ground in the crowd and trampled by a horse. His face and head were mangled, and he died a few days later.

Around 2:00 p.m., Sheriff William Domigan slid the ropes around the condemneds' necks. The *Journal's* editor wrote, "We saw the rope adjusted and turned away, sick at heart. We had seen enough!"

Hester Foster and William Graham were positioned in the front of the gallows and "launched into eternity."

Afterward, the paper appealed to the Ohio legislature to put a stop to public executions, if not executions altogether. Executions did continue, but they took place inside the penitentiary walls.

OHIO'S MADAM

Lizzie (1871–1908)

*L*izzie Rogers-Lape-Huffman-Larzelere-DeWitt-DeWitt-Veon-Shetler-France was probably the most prolific madam in Ohio history. She opened a string of brothels and saloons in so many places across the state that it is hard to keep track. As her name implies, she collected eight husbands along the way, including a father-son duo.

In *Looking for Lizzie*, author Debra Lape wrote about her forty-year search through historical records for her great-great-grandmother.

Elizabeth Rogers was born on August 15, 1853, in Whitley County, Kentucky, to Prior and Cynthia Rogers. At a very young age, she left Kentucky and headed for Chicago, where she went into business for herself in the red-light district. At the time, there was a large influx of Civil War veterans into the city, and the brothel business was good. Then, on October 8, 1871, a fire ignited and flames tore through the city, scorching everything in its path. The blaze lasted for three days. With her business in ashes and nowhere else to turn, Lizzie left Chicago with her "best customer," Jeremiah Lape, a thirty-two-year-old wounded Union veteran.

It was her first attempt to leave her sordid vocation behind. Lizzie and Jeremiah married in December 1872 in Shelbyville, Illinois, and settled in his hometown of Plain City, Ohio, where they rented rooms on Church Street, close to his widowed mother and the police station. He had been hired as the town constable, and she made money tailoring.

A baby boy, Henry Arville Lape, came along in August 1878. For a time, the Lapes were probably happy, but things must have turned sour before

1880. She was still listed in the 1880 census as living in Plain City, but by 1882, she had changed her residence to a boardinghouse on Fifth Street in Columbus not far from Union Station train depot. Throughout her career as a madam, she would set up close to a railroad station. Undoubtedly, trainmen and passengers made good customers. However, at this point, it is not known whether she was supporting herself by "tailoring" or if she had slipped back into her first profession. It is also unknown whether she had little Arville with her, or whether he had stayed with his father.

Her next move was to 16 East Sixth Street in Dayton, where she rented a saloon. Her landlord, Clark McClung, also ran a wine and beer saloon, lunchroom and billiard hall next door at 18 East Sixth. He lived upstairs from his saloon, so perhaps Lizzie served beer downstairs in her saloon and ran a brothel upstairs. It was an optimal spot close to the Dayton Union Railroad Station, and she could offer two vices in one building.

Maybe business in Dayton was not as good as she hoped; after a year, she moved on to Lima, a new husband and a run-in with the law.

Her new husband was a thief named George W. Hoffman. He had been operating the notorious Junction House in south Lima at the crossing of the Chicago & Alton, Detroit & Mackinac and Lake Erie & Western Railroads. After marrying Lizzie, George installed her as the madam of a brothel. Meanwhile, he and his friends, who included Robert Dale and Charles Burton, were the principals of a prolific theft ring. Apparently, this was all right with her—she wore some of the stolen jewelry.

On Saturday night, April 4, 1885, officers from Celina, Mercer County, and Lima forced their way into the house and took Hoffman, Dale, Burton and Lizzie into custody. Several other "inmates" were forced to get up and get dressed and accompany the officers to the city prison. The *Lima Daily Democrat* informed its readership that Mrs. George W. Hoffman went by the "sporting name" of Lizzie Lape.

When police searched Lizzie, they found her with a watch that had been stolen from a local citizen during a burglary on New Year's Eve. Silk dress patterns, silk handkerchiefs, silver spoons, cutlery, bank drafts and postal orders were also seized as evidence. The postal orders led police to question whether the gang might have been involved in a mail robbery at Wapakoneta, but the evidence never connected.

Lizzie, charged with concealing stolen goods, found herself behind bars.

Obviously, Lizzie had worn out her welcome in Lima. She left George and moved to Marion after being released. On April 24, 1886, she bought an establishment known as the White Pigeon saloon from H. Gregory. She

paid $1,000. In December, she purchased a building called the "red house" for $995 in a sheriff's sale from Sheriff Frank Beckley. The former owner was Gregory. The two structures stood side by side on West Church Street, known to some as the "shady side of the street."

The "red house" was referred to as the Red Bird Saloon in *Florence Harding: The First Lady, the Jazz Age, and the Death of the Most Scandalous President*, a 1999 biography of Warren G. Harding's wife by Carl Sferrazza Anthony. Future president Warren Harding took over the *Marion Star* newspaper in 1884. Stories suggest he was a frequent guest at both establishments. Both houses served food and offered gambling and billiards, as well as private female entertainment. Whether Harding and Lizzie knew each other would only be a guess.

Lizzie's next husband was John E. "Jack" Larzelere, who owned a saloon inside the Kerr House Hotel in Marion. According to Harding's *Marion Daily Star* in 1886, Jack and "John Doe" ran into trouble with the law for "selling intoxicating liquors to a person in the habit of getting drunk." The habitual drunk was Henry DeWolfe, the ex-husband of Florence Kling, who later married Harding. The John Doe was not revealed.

Early the next year, Jack sold the Kerr House saloon and went to work for Lizzie at the White Pigeon. A few months later, on May 24, 1887, he and Lizzie were married in Columbus.

Lizzie liked to set up shop close to train depots. This train station is at Marion. *Courtesy of the Marion County Historical Society.*

Warren G. Harding ran the *Marion Star* newspaper. *Courtesy of Ohio History Connection.*

For a while, it was business as usual at the White Pigeon—until the law came to visit on Valentine's Day 1889. Lizzie was arrested for keeping houses of ill fame. Jack and Dan and Martha "Mattie" Fritz, who managed the Pigeon, were also arrested. They bonded out at $800 each, a hefty sum in those days. They went in front of the judge and were found guilty. Jack was sentenced to six months in the Cleveland Workhouse and a $20 fine plus prosecution costs. Lizzie paid $25 plus costs and was sentenced to sixty days in the Cleveland Workhouse.

The Cleveland Workhouse was a fairly new facility located on East Woodland Avenue at East Seventy-Ninth Street. It was known as a progressive penal institution where low-level criminals could work off their fines and court costs by making chairs and brushes.

Whether Lizzie was daunted by the big stone building is doubtful. She was probably set to work wrapping cord around horsehair for brushes.

Sometime after her stint in the workhouse, Lizzie decided to branch out. The Akron area looked as though it held great opportunity. She still owned the White Pigeon in Marion, so she left the Fritzes to run the operation. Dan was more than able to keep the saloon running and handle any trouble that came through its doors. Mattie had a hand in taking care of the "house" next door.

Arrested for prostitution, Lizzie spent time in the Cleveland Workhouse. *Courtesy of the Cleveland Public Library.*

Around this time, Lizzie became embroiled in a lawsuit with her ex-husband Jeremiah Lape over child support for their son, Arville. The court record is buried in history, so it is unknown who filed the case, but it was most likely Jeremiah. Lizzie hired former Akron mayor Lorenzo D. Watters as her attorney. The disposition of the case stated that Lizzie would set up a trust for Arville, using the White Pigeon, and Watters was to be the trustee. Jeremiah Lape died on the day the land transferred into the trust.

To what must have been Lizzie's delight, Akron bustled with opportunity for women of her business acumen. There were more than sixty saloons but only thirty churches. In among the daytime businesses on Howard Street (the main street at the time) were saloons, billiard halls and sample rooms boasting of "choice" hard liquor—and there was "exceptional" entertainment.

With an eye toward climbing the business ladder, Lizzie managed to procure positions for herself and Jack running a combination saloon, restaurant and brothel located in the northern part of Akron. It was referred to as the "Halfway House" because it was midway between Akron and Cuyahoga Falls. It stood at the present location of 700 East Cuyahoga

Avenue. Her new employer was John C. "J.C." DeWitt, a longtime saloonkeeper. He encouraged dog fighting and shooting matches at the establishment, and it was the scene of many drunken brawls.

At the end of May 1890, Lizzie and her husband again found themselves in trouble with the law. The *Akron Beacon Journal* termed it "keeping a house of assignation." This time, fifteen-year-old May Flower was found in the brothel. She had been taken there by an unnamed man and placed in the custody of the "keeper of the place."

Lizzie's case was dismissed, but her husband was fined fifty dollars and court costs.

Marital bliss was fading fast in September of that year, so Lizzie shed her third husband. She took back the Lape name and kept all of her property in the divorce.

She may have been through three bad marriages, but that did not sour her on men. Most likely, Henry C. DeWitt (John C.'s youngest child) had caught her eye long before her divorce from Jack, because they married in October 1890. Henry, nicknamed "Snakes" for his love of gambling, was eleven years younger than Lizzie. The two were wed in the infamous red-light district of Canton. No records show that she ran a bawdy house there. Instead, Harry and Lizzie came back to Akron to run the "Halfway House."

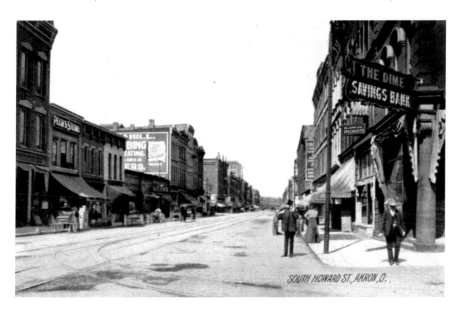

Looking south on a bustling Howard Street, the main street in Akron. *Courtesy of the Akron Public Library.*

For a time, things went well, until February 13, 1891, when she was taken under the wing of the law again. According to the *Akron Beacon Journal*, "Mrs. Lizzie DeWitt, living at a half way point between Akron and Cuyahoga Falls was arrested to-day [*sic*] on the charge of keeping a house of assignation." She admitted the crime and paid fifty dollars plus costs.

Harry lost money gambling, and he was a poor businessman. Worse yet, he could not control his temper. He and Lizzie argued. On the morning of March 19, 1891, Lizzie climbed into her new buggy and tried to leave the house. Harry ran out into the street and stopped the horse, which upset the buggy, wrecking it. Lizzie flew out into the mud.

Lizzie was not going to stand for the abuse; furthermore, she needed to protect her property. Two days later, on March 21, she hired Lorenzo Watters again, to file a petition for divorce, citing extreme cruelty. In addition to the buggy incident, Lizzie complained that Harry slapped her and threw her on the floor. She said he threatened to kill her on numerous occasions. Her petition asked that she keep the household effects. Most important, she wanted to keep the White Pigeon, because it was Arville's trust and was valued at $6,000.

Less than a month later, Mary DeWitt—Harry's mother—died, leaving Harry's father, John, a widower and conveniently free to "love" again. Twelve days after Mary's death, John made application to become Arville's guardian, claiming to be the thirteen-year-old's uncle, which of course was false. Lizzie must have brought Arville to Akron, because he appeared in the Akron city directory at 313 North Howard Street.

Since John was claiming to be Jeremiah "DeWitt's" brother and Arville's uncle, he also filed for Jeremiah Lape's military pension, which was money accruing for the boy. As Arville's guardian, John continued to draw the pension for a period of four and a half years.

Around this time, Lizzie and John began cohabitating, a jailable offense. Harry was livid, so in July he had arrest warrants sworn out for John on a charge of fornication and Lizzie for adultery. The *Akron Beacon Journal* reported the story on July 10. Harry declared that father-in-law and daughter-in-law had been intimate from May 1 (two weeks after Mary DeWitt died) until June 5. They pleaded not guilty and were bound over to probate court and were released on one hundred dollars bond each.

But the fight was not over. Harry broke into his father's house one night and was chased away by gunfire. The next morning, John swore out a warrant for his son's arrest.

In October, Lizzie was granted a divorce from Harry. They had been married one week shy of a year. Three weeks after her divorce, she married John. Whereas DeWitt Jr. was eleven years younger than Lizzie, DeWitt Sr. was eighteen years older.

Lizzie's new marriage did not stop Harry from trying to get revenge on his father for stealing his wife. On Tuesday morning, November 10, 1891, just two days after John and Lizzie's nuptials, Harry accosted them on the sidewalk outside Boder's meat market on 115 North Howard Street. Harry swore at his father and punched him in the face twice. John cursed his son and hit him back. The two pummeled each other until Harry, who was clearly out of control, ran out into the street, screaming for the police to come and arrest him. Both men were carted off to jail.

By the next day, the DeWitts had calmed down and made peace with each other before going to court. Harry dismissed the assault and battery charges against his father, and John provided his son with bail. John agreed not to appear against his son in court if the younger man would agree not to interfere with him and Lizzie.

John had a better business head than his son. And his ambitions seemed to match Lizzie's. This might have been the prominent reason she married

Built in 1843 and torn down in 1905, the Summit County Courthouse was located between High and South Broadway streets. *Courtesy of the Akron-Summit County Public Library.*

him. Originally, John ran a saloon at 526 South Main Street, but he left that address behind to open a new and perhaps more upscale saloon at 728 South Main. He called it a "sample room with imported and domestic wines, liquors and cigars." A while later, he and Lizzie opened the City Liquor Store, a wholesale liquor store at 184 South Howard Street. Things went well. The money was rolling in. Lizzie purchased a house at 169 Bartges. John bought a steamer boat called the *New Republic*. Tied up at Lakeside Park on Summit Lake, it was probably a floating bordello. They were perfect partners.

But something went wrong in 1894. Lizzie wanted out, and she wanted to make sure she kept her part of the properties. According to an *Akron Beacon Journal* report on July 17, she claimed to be a faithful and devoted wife, while John was "guilty of extreme cruelty toward her, in that he used insulting and profane language." The article went on to say that "he failed to furnish clothing for her." She added that she owned $7,000 worth of property and wanted to keep it.

John was fighting back. In hopes that he be awarded the divorce and alimony, he offered two people $100 each if they would swear they had seen Lizzie in rooms with other men.

Lizzie's petition claimed that John had coerced her into a partnership of the City Liquor Store but had failed to keep her informed of the finances of

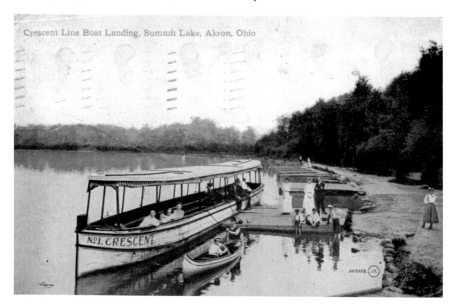

Lakeside Park at Summit Lake was an early and popular amusement park. *Courtesy of the Akron-Summit County Public Library.*

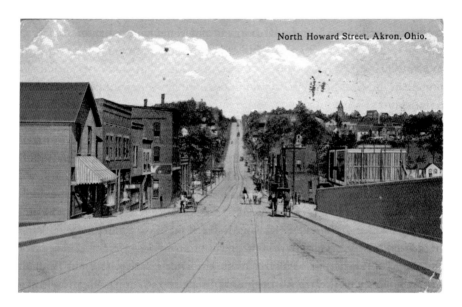

North Howard Street, Akron, Ohio.

What Lizzie must have seen while looking north on Howard Street in Akron. *Courtesy of the Akron-Summit County Public Library.*

the store. So her attorney filed for an injunction to stop him from disposing of any property. She asked for alimony and an adjustment of property rights.

During her legal fight with her fifth husband, she was badly burned when a gas stove exploded on her, burning her hands and face. She must have healed without too much scaring, as her one portrait was taken after the incident.

She left Akron for Columbus for a few months, probably to hide a pregnancy. Certainly, the birth of a child during divorce proceedings would have been hard to explain. A baby girl was born on January 18, 1895, and named Edna Lape. Lizzie was listed as the mother on the birth certificate, but there was no father's name. Beyond a christening in Pickaway County, there is no record of what happened to the child.

In April, Lizzie was granted a divorce with alimony, her property and custody of Arville. She moved to North Akron and got serious about another man.

She had probably known Charles W. Veon for a while, possibly from the Halfway House or from a boardinghouse where they both lived on North Howard Street. Charles was a widower who drank too much and had an arrest record. His wife had died on January 8, 1895, and his three children went to live in North Akron with his parents.

It did not take long for Lizzie to make another commitment. She and Charles were married on July 14, 1895. She may have married five times before, but this time, she must have thought it would be different. This time, she was married in a church—St. John's Episcopal Church in Cuyahoga Falls.

The DeWitts left town and left the City Liquor Store for Lizzie and Charles to run. Lizzie and her new husband added a restaurant, but the establishment was still listed under saloons in the city directory.

Shortly after her church wedding, Lizzie received news that the City of Marion was about to take some of her property next to White Pigeon by eminent domain for access to an alley that abutted the foundation of her building. The city's move may have been a way of curtailing the saloon and brothel business. She hired Akron attorneys Grant & Sieber and sued the city. Marion settled for $500.

At the same time, Marion church groups were waging a campaign against drinking, gambling and prostitution. They were following the lead of Charles Parkhurst, a New York City clergyman well known for his sermons on the evils of prostitution and drink. The Marion church group wanted to see all houses of ill repute closed down for good and their owners and workers arrested. There was little motivation on the part of the police and the courts, however. The fact was that the houses and saloons were a large source of revenue, both tax-wise and fine-wise. And many of her best customers were prominent in the city.

Private detective James McEldowney was quite possibly hired by the church group to watch the saloons and brothels to see if the Winn Law was being broken. The law, which was passed in 1894, prohibited selling or giving away "intoxicating liquors" in a brothel. It was a misdemeanor punishable by incarceration of one to six months and a fine of $100 to $500. McEldowney was most interested in the section of the law where the person who brings the crime to the attention of authorities is due a large reward.

The White Pigeon was in his sights, and he brought the case against Lizzie, Charles and Dan Fritz. Unfortunately for McEldowney, he was caught red-handed with a young woman in his boardinghouse. Forced out of Marion, he dropped the case against Lizzie et al. and the White Pigeon.

A daughter, Mary, was born to forty-three-year-old Lizzie at the end of 1896, and early the next year, the family moved from Akron to Stow. She bought the Cliff House and the surrounding ten acres from Charles and Elsie Kidney. Part of the transaction was funded by a trade of some land Charles owned in Portage County. The rest was mortgaged. Shortly after they moved in, Arville married his sweetheart in a lavish ceremony at the family's new

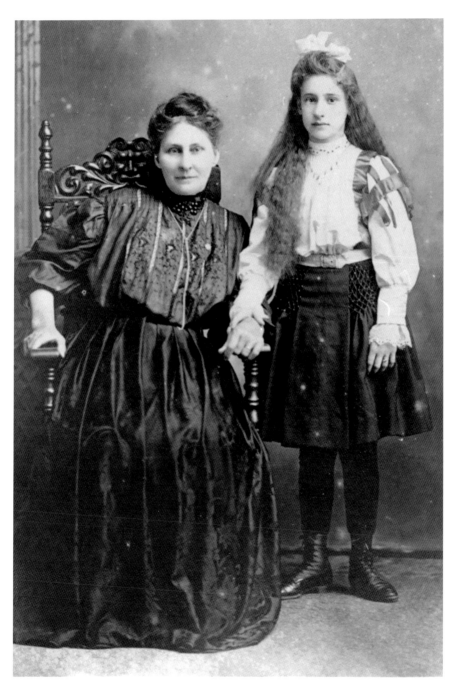

Lizzie Rogers-Lape-Huffman-Larzelere-DeWitt-DeWitt-Veon-Shetler-France. The young girl is most probably her daughter Mary Veon. *Courtesy of Debra Lape.*

home, which they called the Stow Corners Hotel. On that same day, Lizzie decided to be baptized along with her new baby. Reverend Robert Kell of St. John's Episcopal Church officiated at all three ceremonies.

It is possible that Lizzie at the age of forty-three and with a new baby wanted a quieter lifestyle. Although she still owned the White Pigeon in Marion, she seemed to prefer staying in Stow. It may have been obvious to her that her days as a madam were drawing to a close. She sent her husband, Charles, to run the Pigeon's saloon and leased the brothel to Nellie Burke, who had come from Bucyrus under a cloud of infamy. Trouble erupted when a couple of the inmates stole the cook's furs. In addition to being thieves, they were behind in their rent.

Next, the police raided the place in the early-morning hours of May 4, 1897. "Monday night crowds visited the disreputable place in swarms," according to the *Marion Daily Star*. "They went early and stayed late, and were making right hideous about the premises when Marshal Blaine and the entire police force made their raid."

Officers surrounded the house and made a "grand and unexpected entrance." The article claimed that at least twenty-five people were there. Police said they scrambled to find hiding places behind trunks and under beds. All but two women and seven men escaped. In court, Nellie paid twenty-five dollars and another woman paid ten dollars. Since the men were not expected to show up for the court date, each deposited ten dollars. Lizzie went to Marion in the afternoon and pleaded guilty and was fined ten dollars and costs.

Nellie was made to leave town. There are no records to show whether Lizzie found another madam to run the house. She and Charles opened up another saloon on Kenton Street in Marion near the depot. There was a boardinghouse conveniently located across the street, but it is not known whether Lizzie ran it. Arville was running the White Pigeon, and Lizzie helped her son with the restaurant. On one occasion, she saw a customer stick his fingers in the food, so she struck him with a dish.

It was not long before trouble was brewing at the Cliff House in Stow. The do-gooders were catching up to Lizzie and Charles; the two were arrested in August 1897. Lizzie was released, but Charles spent the night in the Summit County Jail. She did not post bail for her husband. Instead, his father, Robert, bailed him out to the tune of $200. Charles was arrested again in October, found guilty and sentenced to time served (one day) in jail.

Charles was drinking more and more and becoming a liability. He left Stow for Marion and began making a nuisance of himself at the White

The Marion County Courthouse was familiar to Lizzie for a variety of reasons. *Courtesy of Ohio History Connection.*

Pigeon. In the meantime, Lizzie was traveling back and forth between her businesses in Marion and Stow. She left Dick Underwood, her daughter-in-law's uncle, in charge of the Cliff House when she was in Marion. While she was gone in August 1898, the Stow property was raided and Underwood was taken to jail for selling "intoxicants in a dry township." He pleaded guilty and was fined seventy-five dollars.

Lizzie did not post his bail or pay his fine. Instead, she turned around and sued him for "selling liquor on her property" and refusing to vacate the premises, according to the *Akron Beacon Journal*.

Next came a legal battle with the Summit County Treasurer's Office. The treasurer advertised the Cliff House for sale for short payment of the Dow Tax, sometimes called a "sin tax" enacted on drinking establishments. In addition to her woes in Summit County, two creditors were suing Lizzie in Marion. Next came an article in the *Akron Daily Democrat* informing its readership that her husband, Charles Veon, was a registered drunk.

Things went from bad to worse. On Friday September 1, 1899, at 2:00 a.m., someone set the Cliff House on fire. The papers reported that the fire was of "incendiary origin," but there is no record of an arrest. Lizzie's loss was about $2,000. Great-great-granddaughter Debra Lape offered a few theories: the people of Stow were trying to rid the town of vices; Dan Underwood was seeking revenge; or Charles's resentment was growing as he and Lizzie were drifting apart.

There was one other possibility. The mortgage holder, Jane Steinbacher, hurried to file a foreclosure suit. Her history as a mortgage lender involved at least one other fire. And then there was Lizzie herself. The Cliff House stood in a "dry" locale, so she could no longer run it as a saloon. She did have an insurance policy on the building through the British Merchant Insurance Company, and cash was something she needed. However, the policy stated that it would not pay if liquor was on the premises. She denied that liquor was in the building and brought suit.

Three weeks later, she bought a house in Marion not far from the White Pigeon, but she didn't stay long. Instead, she had her eye on a new town in Ohio—Shelby in Richland County. On January 1, 1900, she bought a saloon and restaurant. Actually, it was an existing brothel with a reputation to match. It stood on North Broadway on the Baltimore & Ohio Railroad track, two doors down from the Big Four Railroad Depot. It was a prime spot in a growing town with other boardinghouses, saloons, mills and manufacturing.

It did not take too long before she was arrested and hauled before Mayor Long of Shelby. The mayor was known to give a good lecture and advice to lawbreakers before pronouncing sentence. He reminded her that she was getting too old for her profession and asked her if she wanted to be a madam the rest of her life. He also reminded Lizzie of her daughter and asked her what kind of an example she was for the ten-year-old. Lizzie broke down and cried.

It was time to shed husband number six. Lizzie claimed that Charles had committed adultery with a woman named Mamie Gardner in Marion. Her lawyers asked that she retain all her properties, household goods and custody of their daughter, Mary. As always, she got what she wanted.

Lizzie continued to run the brothel in Shelby for a while but sold it to move back to Marion. She could not stay single for long. Before she left Shelby, she married William B. Shetler, a divorced father of three, in Kentucky. He was twenty years her junior. They moved into her house in Marion at 430 West Church Street.

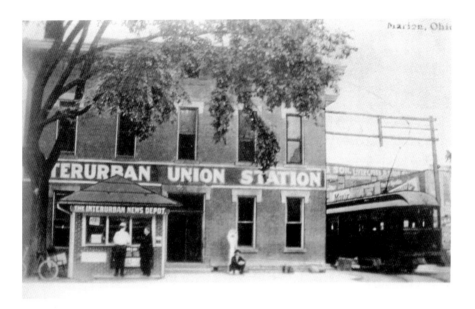

The Interurban Union Station in Marion. *Courtesy of the Marion County Historical Society.*

Arville, who was running the White Pigeon, had begun to drink. He was embroiled in a divorce with his wife and came up missing at one point. But Lizzie's worst nightmare was yet to come. Her son was arrested for burglary. He pleaded guilty and was sent to Mansfield Reformatory. It was up to Lizzie to go back to Marion to run the White Pigeon. All the old troubles with renters and police raids reared their heads.

By 1901, most of the churches in Marion were on the east side of town. The factories, manufacturers, cheap boardinghouses and saloons were on the west side. So was the White Pigeon. That changed when the Wesley Methodist Episcopal Church was built a block over on land donated by John and Edward Huber, owners of Malleable Iron Works.

Lizzie got religion in 1903, as evidenced by a letter she wrote to Mayor Long in Shelby. She wrote, "These words you spoke to me in kindness have haunted me ever since." She must have been serious, because an article in the *Marion Daily Star* on March 17, 1903, reported that she had "tendered the use" of the White Pigeon and her saloon for the use of the Wesley Methodist Episcopal Church as a mission. She pledged that those buildings would never be used for immoral purposes again.

Soon after she gave the church the use of her buildings, Arville was paroled from Mansfield. If he was ever to make a go of a solid life, he needed a

job. He got work at Malleable Iron Works, the company whose owners had donated property to the church. Perhaps this was a coincidence, or maybe Lizzie knew what she was doing.

Lizzie and William sold the White Pigeon to a farmer named Weir in 1904. Two years later, it was back in business and the police were raiding it.

The newlyweds were tiring of each other by 1905, and Lizzie filed for divorce on the grounds of gross neglect of duty. He counter-filed, asking for alimony and citing her "conduct" in Marion. She won, as she always did, and was awarded $200 alimony.

Ever the romantic, Lizzie married one more time, on May 19, 1908. His name was John D. France, a widower of New Cumberland in Tuscarawas County. It is not known how they met. Before the nuptials took place that morning, she purchased twelve acres of land in Greenfield Township in Huron County. The purchase was for $800 in her name alone. The couple then went to the Norwalk Baptist Church and repeated their vows.

Lizzie lived on France's farm in New Cumberland until she dropped out of sight and off of vital records searches. The last that was heard from her was about 1918. Until that time, she wrote letters to her grandson who lived in Akron, and he wrote about her in his diary. Her husband—the last that we know of—John France, was listed in the 1920 census as a widower, but he could have been divorced from Lizzie and considered himself a widower because his first wife had died. Debra Lape carries on the search for her great-great-grandmother. So far, she has not found a death certificate, an obituary or a grave.

4

THE LOVE PLOT

Jean Maude Lowther (1930–31)

Clara Smith thought she was going to spend Memorial Day 1930 with family in Austinburg. She packed her two children into the cab of her husband Tilby's one-ton dump truck and climbed into the seat beside him. With three-year-old Frederick on the seat between them and three-month-old Donald nestled in Clara's lap, the couple left their Dwight Avenue home in Ashtabula in a cold, drizzling rain on Thursday, May 29, around 8:00 p.m.

They drove along South Ridge Road toward Cleveland. A few miles west, they stopped at a filling station owned by Wilbur Smith, Tilby's brother, and chewed the fat for a few minutes. Then Tilby got back behind the wheel and steered the truck south down a lonely stretch of the Saybrook Center Road.

From out of the dark rain, a woman appeared on the left side of the road. She was holding a gun. She told Tilby to get out of the truck and walk around back. He complied.

Then she shot Clara in the right temple at point-blank range. Clara slumped forward, and the baby slid from her lap to the floor of the truck. The older child, who had been sleeping, awoke and began to wail. The trigger woman disappeared back into the soggy darkness.

Tilby hauled his wife's body out of the truck and laid her on the wet, muddy ground. He took the children and ran back to his brother's filling station and called for help.

After police took Clara's body to the morgue in Geneva, they and county prosecutor Howard N. Nazor sat down with Tilby Smith at the police station.

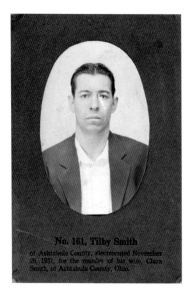

No. 161, Tilby Smith
of Ashtabula County, electrocuted November 28, 1931, for the murder of his wife, Clara Smith, of Ashtabula County, Ohio.

Tilby Smith was electrocuted for the murder of his wife, Clara Smith. *Courtesy of Ohio History Connection.*

Authorities quickly realized that Tilby's detailed account of the shooting did not match the facts. He said that after driving a short distance down Center Road, he saw a parked car. Three men got out and held them up. Neither he nor his wife had money or anything else of value on them. After searching Tilby and finding nothing, one of the men shot at him. He "ducked," and the bullet hit his wife. One of the robbers exclaimed, "My God, you've killed that woman," Tilby related.

Suspicion grew. For one thing, there were no tire tracks in the mud to suggest another vehicle had been in the area. Nazor and Sheriff Frank Sheldon continued to question Tilby into the early-morning hours.

"I surmised that Smith had been having an affair with a woman and on a hunch I shot it at him," Nazor told a *Plain Dealer* reporter.

Described in the papers as "dour, black-haired, weak-chinned, loose mouthed and hollow-chested," Tilby Lafayette Smith, twenty-six, broke down and admitted to an affair. "Yes. But the only girl I've had anything to do with was a girl named 'Marie,'" Tilby insisted.

Nazor, a Cornell Law School graduate, was a workaholic and no fool. He was not satisfied. He knew there was more. He kept questioning.

At one point, Tilby changed his whole story and admitted buying an old .32-caliber revolver that was in bad shape. It was even missing the trigger guard. He claimed that "Marie" was in the truck with him one day and saw the gun. She snatched it away from him and bolted from the truck.

Tibly said "Marie" knew that he and his family were going to Austinburg and what time they were going. He claimed that as his truck approached that part of the road where the murder took place, "Marie" jumped out onto the road and leveled the gun at him. "Put up your hands and get around back of the car," she barked. While he was behind his truck, "Marie" shot his wife, Clara, Tilby declared.

Later in the interrogation, Tilby admitted lying about the woman's name. "If I told you the truth now, you wouldn't believe me," he said to

Sheriff Sheldon. Her real name was not "Marie"—it was Maude, he said. They met at the picture show in Jefferson and had carried on a two-week love affair. He claimed that Maude was "insanely jealous and had threatened to kill him." The sheriff told a *Plain Dealer* reporter that Tilby was "very much afraid of her on account of her having Indian blood in her, and that she was very jealous of his wife."

"Maude was very much in love with me," Tilby told the sheriff.

On his way to the morgue with the body that night, Patrolman Harold Coats remembered passing a woman walking along the road toward Ashtabula. He recalled that she was wearing a black rain slicker and blue knit cap.

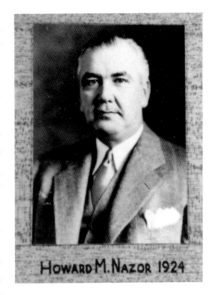

Howard M. Nazor successfully prosecuted both Tilby Smith and Maude Lowther. *Courtesy of the Ashtabula County Law Library.*

The *Star Beacon* reported that the authorities went to the home of the Hubbards, a respected Ashtabula family, where Maude was employed as a maid. Police knew of Maude and where she worked because over the previous two weeks, officers had seen her and Tilby at different spots in town in compromising positions in the seat of his truck. Authorities found Maude, the rain slicker and the knitted cap at the house around 4:00 a.m.

Her full name was Mrs. Jean Maude Lowther. She was twenty-two and described as being a quarter American Indian in almost every news article having to do with the case. Because of her Indian heritage, she supposedly had a quick temper. She had high cheekbones, straight dark hair and dark eyes. One article said she had unusually large front teeth.

Maude came to Ashtabula from Clarksburg, West Virginia, two years before with Alva Lott Lowther, her second husband, from whom she was estranged. She had a seven-year-old son, having been married the first time at fifteen.

When asked where she was the previous evening, she claimed to have been at the movies. Nazor asked her what movie she saw and what it was about. "I'm not in the habit of telling people what I see in picture shows," she answered.

After more questioning, she realized she was in trouble. According to an article in the *Plain Dealer*, she gave Nazor her account. "Well, I'll tell you the truth about this. I shot this woman and he [Tilby] put me up to it. Furthermore, I'll tell you where the gun is. It's in a hatbox in the playroom at the home where I work.

"Smith said he wanted to get rid of his wife. He wanted to go away with me. A few days ago, we had planned to take the mercury out of a thermometer and put it in Mrs. Smith's coffee. But instead we planned this shooting."

She told Nazor that she hiked in the rain that night to a spot near the New York Central Bridge, where Tilby picked her up about 6:30 p.m. He drove her out to a lonely spot on Center Road where she hid in the wet bushes for two hours waiting for Smith's truck to come along.

Tilby denied driving Maude to the murder scene. He claimed he was bidding on a trucking contract at that time. He signed a statement telling how Maude had shot his wife, but it made no mention of his part in the murder plot.

Sheriff Sheldon arranged for Tilby and Maude to meet at the Ashtabula jail. He told the papers that she lashed out at her lover once they were face-to-face. "You rat! You double crosser. That's just like you men—trying to hide behind my skirts."

She told the sheriff that Tilby had come to her the night before the murder and given her the gun. "Use this," he said. After she shot Clara, she stood there not knowing what to do. Tilby yelled at her, "Get the hell out of here."

On Sunday, June 1, Clara Unangst Smith, twenty-eight, was buried in Orangeville, Trumbull County. Tilby did not ask to go to the funeral services. Instead, he spent the day playing cards and joking with other prisoners in the Jefferson jail.

Looking into Tilby's background, Sheriff Sheldon found he had spent three months in the Mercer County, Pennsylvania jail for eliciting a $300 bribe. While serving as an undercover agent for that county, Tilby offered to not testify against a man accused of violating liquor laws.

Both Tilby and Maude were talkative when the press came around to their jail cells. Tilby was especially open. He told a *Piqua Daily Call* reporter that he did not take Maude to that lonely spot on Center Road where Clara was murdered. He said he had an alibi for Thursday, March 29, between 6:00 p.m. and 8:00 p.m. He claimed he was bidding for a trucking contract. He told the reporter that he was confident he would "escape the chair."

When the reporter asked Tilby's attorney, Carey S. Sheldon, about the alibi, Sheldon said he had not spoken with his client yet and that the alibi was "news to him." After that, Sheldon and co-counsel Dennis F. Dunlavy denied any visitors for the two. The two attorneys were neighbors in Ashtabula and worked together often. They said their clients "had already talked too much."

Maude appeared to have no concerns about her case. She made friends with Josephine Witlicki, eighteen, a farm girl from Wayne County. Josephine, the only other female in the women's section of the jail, was doing thirty days for resisting arrest. Maude said they were having a "great time together." She even confided in Josephine that she still loved Tilby. While incarcerated, Maude kept tabs on her weight, checking the scale as often as possible. She also spent time embroidering and showed off her needlework to the press.

Maude would talk to the press about anything except her son. When the boy was mentioned, she became emotional. And she would not see or talk to her husband, Alva Lowther, a construction worker. Apparently, the feeling was mutual, because he did not want to see her either. He refused to help her in any way. "I will have nothing to do with her," he told the papers. "She'll have to get out of this the best way she can. I'm through with her." However, he was among the crowd at the arraignment.

The grand jury indicted both lovers for first-degree murder. They were arraigned before common pleas judge Charles R. Sargent. Sheldon and Dunlavy entered double pleas of not guilty and not guilty by reason of insanity on behalf of the pair. As seasoned attorneys—Sheldon with eighteen years in the courtroom and Dunlavy with twenty-four years before jurors—they knew this was going to be a fight.

During a conference in the judge's chambers, the defense attorneys asked for special treatment for Tilby. Tilby had been evaluated by three psychiatrists. Dunlavy wanted him to plead guilty and waive his right to a jury trial, leaving the judge to decide the degree of guilt. Sargent denied the motion, saying, "It has been discovered by alienists [psychologists or psychiatrists] that this defendant has the mind of an eight-year-old child, and in my opinion, such a person is not capable of waiving his right of trial by jury." Sargent also refused a plea of guilty of homicide. Attorneys then asked for a change of venue. Sargent denied the request.

On the day that Tilby's trial opened, the courtroom was jammed to capacity with curious spectators—mostly women and some children. Press correspondents from around the state were seated in a special section.

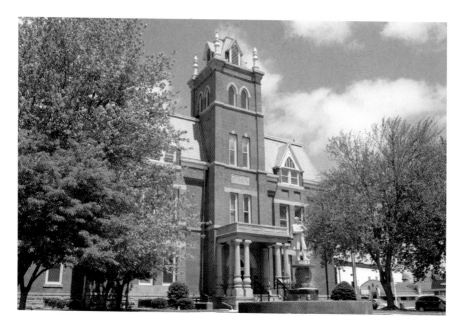

Ashtabula County Courthouse. *Photo by Carl E. Feather.*

When Maude and Tilby were led into the courtroom by deputies and seated, they did not look at each other. He was dressed in a light-green shirt with rolled-up sleeves, a colorful tie and blue pants. He wore checkered socks and held a cap in his hands. Maude wore a sleeveless blue dress and black-and-white flats.

Seating a jury was difficult. The first seventy-five potential jurors were excused, and sixty-three more were called up. Many of the veniremen admitted they had preconceived opinions. Others were firmly against the death penalty. Prosecutor Nazor demanded a jury that was not afraid of imposing the death penalty if the evidence warranted it. Some jurors were let go for preemptory challenge, some for cause. Thirty more were summoned. Twelve men and an alternate were finally chosen.

Maude, wearing a childish yellow dress, sat passively chomping gum. On the way back to her jail cell, she joked with the reporters and posed for photos. Tilby fidgeted nervously but told reporters he felt "swell."

Prosecutor Nazor's opening statement came on July 11. The jury learned that the defendant had worked undercover in Mercer County, Pennsylvania, but he had met his wife, Clara, just across the Ohio border in Orangeville. After they married, they lived with her family for a while before moving to Ashtabula, where Tilby began running a filling station.

After their two children were born, he started a trucking business.

Nazor then laid out a list of witnesses who would testify to seeing Tilby and Maude on different nights in North Park and other occasions in his dump truck. The prosecutor said the lovers had met at the movie theater, passing candy to each other over an empty seat a mere ten days before they planned to murder Clara Smith.

Defense counsel Carey S. Sheldon painted a different portrait of Tilby during his opening statement. According to a *Plain Dealer* reporter there to cover the trial, Sheldon started by saying, "The facts as given by the prosecutor will vary in some particulars, but not a great deal," he said. "His [Tilby's] actions have been so ridiculous, so pathetic, that you will be convinced that his mentality has been greatly impaired or that he never had any."

Defense attorney Carey S. Sheldon Esq. *Courtesy of the Sheldon family.*

Tilby did so poorly in school that he was withdrawn in the seventh grade at the age of seventeen. "He failed in the gas business three times. And he should have been doing his trucking business in a little red wagon," attorney Sheldon said.

The defense would call alienists to testify that Tilby's mentality topped at the age of eight and a half. They insisted the defendant was not smart enough to plot this murder. "This boy may be guilty of manslaughter or second degree murder—but nothing else."

On the next court day, Nazor introduced eighteen witnesses. One was Ashtabula dentist S.H. Bigler, who unknowingly gave Tilby the old gun that was used to end Clara Smith's life. Tilby obtained the gun when he went to the dentist for an examination. After eliciting information about mercury, he saw the pistol lying on top of a pile of junk. "What caliber is it?" The dentist said he did not know. When Tilby asked if he could have the gun, the dentist gave it to him.

The next witness was N.C. Chapman, who worked in an Ashtabula hardware store where Tilby bought a box of .32-caliber cartridges for the

gun. Before leaving the store, Tilby asked the clerk if he thought the liquid inside thermometers was poisonous.

Nazor entered the pistol into evidence. It was noted that near the handle was an inscription: "Terror."

Police officers were called to the stand and testified seeing the lovers in the cab of the dump truck prior to the murder. The two had been seen on Main Street one evening and at least three times in the park across from city hall. Patrolman Harold Coats testified that he took Clara's body to the morgue in Geneva. There was blood all over the side of her face, he said. A glance at Tilby showed him yawning.

The defendant fell asleep during Deputy L.C. Kelsey's testimony the next day. Kelsey was a witness to Tilby's various confessions and to Maude's confession. Kelsey corroborated Sheriff Frank Sheldon's and other officers' testimony on how Tilby took his wife's body out of the truck "like that of a dog" and failed to take her to a hospital.

During cross-examination, Sheldon tried to show that a normal person of normal intelligence would have taken his wife to the hospital.

On the day the defense opened, park benches had to be brought into the courtroom to accommodate the growing crowd, and Judge Sargent encouraged all children under sixteen to leave the courtroom.

Dr. Henry H. Goddard, an Ohio State professor of abnormal psychology, was a witness for the defense. In a matter-of-fact tone, he testified, "I couldn't conceive of a boy of his mentality originating such a plan." As the past director of the Ohio Bureau of Juvenile Research, he had examined anywhere from twenty thousand to thirty thousand people of "feeble intellect."

Nazor asked if it was possible for Tilby to "feign ignorance?" Goddard smiled condescendingly and said, "No."

Cleveland alienist Dr. John Tierney called Tilby a "moron of the lower order." He testified that Tilby "knew the difference between right and wrong only up to the level of his deficient mental development." He said the defendant had the mental capacity of a child between eight and nine years old.

Nazor pointed out that Tilby had run a business and been able to write checks. Tierney answered, "A feeble-minded person may conduct a business and might write checks. And his business might go to smash."

Western Reserve University's Dr. Louis J. Karnosh was the third alienist to testify. He said Tilby was between a "high-grade imbecile and low-grade moron."

The Conneaut high school principal, Professor G.T. Barnes, administered the Binet-Simon test (an intelligence test now known as the Stanford-Binet Intelligence Scale) to Tilby. It, too, found his mental age to be about eight.

Tilby's former teachers offered testimony that they passed him along because of his age. One teacher remarked that on a fifty-word spelling test, Tilby got only four words right. "He never passed his tests," she said.

After that, the defense rested, but Nazor was not finished. He brought two psychiatrists to the stand. Dr. H.H. Drysdale of Cleveland felt Tilby was capable of planning and carrying out the murder.

A question to Arthur J. Hyde, superintendent of Massillon State Hospital, brought Dunlavy to his feet with an objection. Nazor asked Hyde if any of the "crazy people" at the hospital could sit through a trial as Tilby Smith had. Judge Sargent sustained the objection. Neither witness had been permitted to examine Tilby; however, in their expert opinion, he would not have been able to carry on a trucking business or plot a murder unless he was somewhat normal—and further, his facial expression was not symptomatic of a moron.

From the beginning, the trial had been dramatic. And prosecutor Howard M. Nazor would not disappoint the six hundred spectators who sat in the hot, overfull courtroom to hear his closing argument. Lynn Heinzerling for the *Plain Dealer* covered his remarks.

He pounded his fist on the prosecution's table and said Tilby Lafayette Smith must die. He called the murder "one of the most atrocious crimes the world has ever known." The paper said he pleaded and cajoled. Nazor called the murder a "well-planned act of a normal mind."

"If he could deliberate is not the question," the prosecutor shouted and waved his fist, "because he did deliberate. If this case does not warrant the death penalty, we may as well wipe the law off our statute books." With that, he sat down.

Sheldon's closing argument was eloquent, according to the papers, but not as fiery. In talking about deliberating right and wrong or planning the crime, he said, "This is not a question for the layman or the prosecutor or me to decide. It's a question for scientists."

After five days of hearing the evidence, at 2:33 p.m. on July 18, the twelve jurors began to deliberate Tilby Smith's fate. At 3:08 p.m., just thirty-five minutes later, they filed back into the courtroom with their decision. He was guilty, and he should pay the ultimate penalty.

Frederick H. Tilby had sat behind his son throughout the trial. When the verdict was read, his head fell to his chest and he wiped away a tear, then he covered his eyes with his left hand. A gray-haired woman (possibly Tilby's stepmother) reached over and patted his shoulder.

Sheldon and Dunlavy petitioned the court for a new trial. They claimed Judge Sargent erred when he refused to allow Smith to plead guilty to

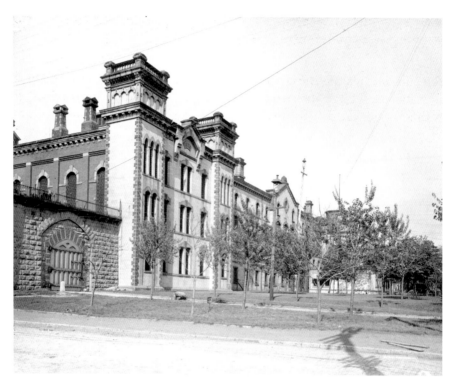

The Ohio State Penitentiary. *Courtesy of the Library of Congress.*

homicide and waive his trial by jury. The district court of appeals reversed the conviction on the grounds that Tilby's constitutional right to waive a trial by jury was violated. Prosecutor Nazor appealed the reversal to the Ohio Supreme Court but lost. Tilby was tried a second time before Judge Sargent with the same outcome. Tilby Smith wept as he was strapped in the electric chair at the Ohio State Penitentiary on November 20, 1931.

Jean Maude Lowther went on trial at the beginning of June 1931. Prosecutor Nazor asked for the death penalty, even though Clarence Darrow cautioned him against it. Darrow—who was originally from Kinsman—and Nazor, along with other attorneys, always had lunch at the same deli, where they would discuss business. During one of those lunches, the famed attorney of the Scopes Trial told Nazor that a jury would never sentence a woman to the chair. But if Nazor got his way, Maude would be the first woman in Ohio to die in the electric chair.

While the all-male jury went to view the murder spot on Saybrook Center Road, the spectators watched as Maude's family filed into the courtroom.

Carl Ross, Maude's father, brought her eight-year-old son, William Earl Frush, with him. Dressed in a blue suit and wearing a sailor hat, the boy wrapped his arms around his mother. Maude rarely showed emotion, but she burst into tears as she kissed the little boy she had not seen since coming to Ashtabula. Tears dribbled down her cheeks as she and her son sat together with arms entwined. This was not what Nazor wanted the jurors to see as they filed back into the courtroom. Judge Oglevee, assigned from Carroll County to hear the case, agreed and ordered the boy removed from the defense table.

The *Star Beacon* reported that Nazor sought to enter Maude's written confession into evidence. Her attorney, Frank L. Marvin of Jefferson, fought to keep it out. The jury was excused from the courtroom while the prosecutor and defense attorney launched into a heated argument. Frank Sheldon, the former sheriff, had obtained the confession and contended that Maude was not threatened in any way or promised anything, but Marvin insisted it was not voluntary. Judge James Oglevee eventually did allow it and said the jurors could decide for themselves whether it was voluntary.

The former sheriff testified that Maude first claimed to be at the motion picture show at the time of the murder, but she could not relate the movie's plot. She also denied at first knowing Tilby Smith, but police had seen them around town together. Under police questioning, Maude admitted she knew two young children would be with Clara in the truck. She signed the confession "because everyone was so courteous toward her." Deputy L.C. Kelsey wrote the confession out, and the sheriff and another officer witnessed it. "Both of us are equally guilty," the former sheriff recalled Maude saying. "Give me a gun and leave us [Maude and Tilby] alone and you'll have another murder on your hands."

Patrolman Harold Coates testified that he had seen a woman who looked like Maude walking along the road away from the murder scene. He told the court that he was present when Nazor told Maude that Tilby had named her as the trigger woman. He was one of the officers who collected the murder weapon from the home where Maude worked. Two Ashtabula policemen were recalled to testify to finding Maude's rubbers in a field near the scene.

As the state presented its evidence, Maude seemed listless. Other than smiling at her attorney a couple of times, she sat slumped at the defense table, working over her wad of gum. She wore a new white-and-orange print dress that she made to pass the time while behind bars. Periodically, she stole a look at the witnesses and yawned.

Five hundred people packed the courtroom on the day Maude took the stand. The *Star Beacon* reported that she testified in a strong voice. "I fired the fatal shot because I loved Tilby Smith," she admitted upon questioning from her attorney. "I was willing to do anything for him."

"After I fired the shot, I stood as struck until Tilby came from around back of the truck and told me to 'get the hell out of here as fast as you can.'"

"Is it not true Tilby appealed to you in a sex manner more than any other?" her attorney asked.

"Yes." Further questioning brought out that she had been intimate with sixteen different men. "But Tilby told me that he would take care of me and my son and that we would go to Florida after this thing blew over."

Under Nazor's cross-examination, she said, "I went around to the other side of the truck and fired at the outline of a woman." She denied knowing beforehand that the children would be in the truck.

She said her love for Tilby turned to hate when she realized he had "squealed" on her. She admitted that she had called him a doubled-crosser but denied threatening to kill him. She blamed Tilby for the entire plot.

The jury was out a scant two hours. During that time, they voted four times. The first ballot was unanimous on guilty. It took three more ballots to be unanimous on the sentence. Three jurors favored mercy. The other nine wanted death. They won.

The color drained from Maude's face when she heard the verdict. She continued to chew her gum but sat stoically next to her attorney. As people filed out of the courtroom, a few could be heard saying, "She got what she deserved." Before court that day, she told her grandfather that she would rather die in the electric chair than go to prison for life.

Ten minutes later, as she walked from the courthouse to the jail, she was laughing. As the reporters and photographers started to file into the jail, she laughed as she greeted them. "Hello boys. I have posed for enough pictures to paper this room with," she said, according to the *Piqua Daily Call*. "The pictures never look good anyway. No, I won't smile for you."

Maude asked her attorney and Sheriff C. Herman Blanche to pose with her. "Get right up close to me. I won't mind."

Marvin appealed the verdict and asked for a new trial.

State welfare director John McSweeney told the papers, "Mrs. Lowther's execution, if carried out, probably will be the most expensive electrocution in the history of the state." Because the Ohio Penitentiary lacked accommodations for a women's "death row," the state would have to make special preparations and hire the services of female attendants. He estimated

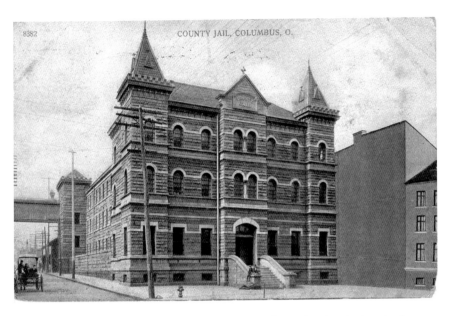

Maude Lowther was held in the Columbus jail because the penitentiary had no death row accommodations for women. *Courtesy of the Columbus Metropolitan Library.*

the cost to be about $2,000. She was held in the Columbus city jail awaiting a decision by the appellate court.

The Seventh District Court of Appeals granted Maude a new trial. The appellate court held that five of the trial court jurors had expressed opinions that she was guilty during their examination. They said they would disregard these feelings and were seated over the defense's objection.

Maude was also granted a change of venue from Ashtabula County to Wayne County by Judge A.W. Overmeyer of Fremont. Her second trial began in December 1931. During the voir dire, she decided to plead guilty to homicide and waive a trial by jury. During the hearing, Judge George A. Starn listened as Maude's lawyer, Frank Marvin, spoke of her pathetic background.

Carl Ross, Maude's father, was a harsh man. At times, it seemed as though he hated his children. He was especially hard on Maude. She was the eldest of six and was made to take care of all the livestock. Whenever she earned any money, her father took it. She wanted to take business courses, but he would not hear of it, saying she was needed on the farm.

Maude had no friends as a child. Girls her age scorned her because she was shabbily dressed and her feet were bare. When she tried to make friends, they laughed at her and made fun.

When Maude was fifteen, her twenty-two-year-old cousin, Earl Frush, came to work on the farm. He was nice to her and sweet-talked her. Nine months later, her son was born. Her father was furious. The family physician forced the two to marry before she was even out of bed from giving birth. Her second husband was twenty years older. She married him "because her father thought he could give a home to herself and her child."

Judge Starn spared Maude the electric chair and sentenced her to life at the Marysville Reformatory. Her demeanor changed with the new sentence. "I am anxious to go," she told the papers. "I want to get down there and get settled. I hope I will have a chance to get outside in the open air and the sunlight when I arrive there. I have had very little sunlight in the past nineteen months."

"I am going with the intention of liking it," she said. "That is if anyone can like being in such a place."

Maude served twenty-two years in Marysville, seventeen in the maternity ward. On Easter 1954, Governor Frank J. Lausche commuted her sentence from first-degree to second-degree murder, which made her eligible for parole. She was released.

She worked as a nursing aid and lived in Columbus for a while. She married and became Julia M. Kroninger. She died on November 30, 1993, at the age of eighty-five and is buried in Greenlawn Cemetery in Columbus.

WITHIN THE SCAFFOLD'S SHADOW

"Big Liz" Carter (1890)

"Big Liz" Carter was not going to lose her man to another woman. Not after eighteen years of history with him that included two babies who died and the adoption of a third.

In 1890, she and forty-year-old William "Bill" Taylor lived in a tenement house at 247 Central Avenue at the corner of George Street in Cincinnati. Liz had a bad reputation in the neighborhood for being a key figure in a knifing and two shootings—all for the sake of love.

A news article in the *Cincinnati Enquirer* told of the knifing during a fight with a female rival. Liz was arrested for the cutting but was acquitted at trial when it became evident the victim's wounds were administered by the heel of Liz's shoe. During one domestic row with Bill, she shot him, but the wound was superficial, and he refused to prosecute. Lizzie herself was shot three times trying to protect Bill when a man held him at gunpoint. She sprang between them just as the gun went off. She was hit by three bullets. One of those bullets remained in her body the rest of her life.

By August 1890, Bill Taylor was tired of the domestic struggles, her jealousy and her temper. He had grown weary of what she called their "lovers' spats" and was turning his affections toward a woman known only as Frances.

Born in Glasgow, Georgia, of slave parents, Big Liz was tall and weighed in at somewhere around three hundred pounds. When she got wind of Taylor's affair with Frances, she hunted down the unlucky woman and gave her a thrashing. On Tuesday, August 12, she went looking for Bill and

found him down around the boat landing. The *Cincinnati Commercial Tribune* reported that she told him he would not live with any other woman but her. Things then turned violent. He tried to break a chair over her head. She went after him with a butcher knife. Liz measured six feet around the bosom and five feet around the waist. Bill, described as "quite slight in figure," dropped the chair and ran. Although she chased him for several blocks, he got away.

The next day, they got back together, and all seemed well. But later on that Wednesday, Bill fell desperately ill. He got worse as the evening wore on, so Liz called Dr. J.S. Cardwell, who lived a short distance away on Seventh Street. Cardwell thought Bill's symptoms were consistent with cholera morbus (acute gastroenteritis). It was no use; Bill died somewhere between 12:00 a.m. and 2:00 a.m. Dr. Cardwell signed the death certificate listing cholera morbus as the cause of death and dated it August 15.

Bill was prominent in the "colored Masons," and his funeral the following Sunday reflected that. Liz was inconsolable. She dressed herself in black and wailed in sorrow.

It did not take long before rumors surfaced. Whispers that Bill Taylor had been poisoned grew to loud talk among the neighbors. An August 22 article in the *Cincinnati Inquirer* reported that a man named George Rankin began to hear the rumors and thought he should step forward and tell what he knew. Coroner John H. Rendigs was interested in his story.

According to Rankin, who called himself a musician and a jack-of-all-trades, the night before Bill Taylor died, he (Rankin) was standing at the corner of George and Central about 10:00 p.m. when "Big Liz" approached. She asked him to buy her a box of "rough on rats" and a bucket of beer. She gave him fifteen cents. He hustled over to a place on the northeast corner of Sixth Street and Central Avenue, made the purchases and brought them back. Rankin claimed Big Liz cautioned him to keep quiet.

Rankin's story was enough for Coroner Rendigs to take action. The coroner rode out to the Union Baptist Cemetery (then known as the "colored" cemetery) on Warsaw Pike to order Bill's body exhumed. Rendigs was surprised when the sexton refused to point out Bill's grave or to allow it to be opened without the superintendent's written permission.

Instead of arguing with the sexton, Rendigs returned to the city and ordered Liz's arrest. Police went looking for her but learned she had disappeared after the funeral. A few nights later, she walked into Central Station, claiming to have heard that the police were looking for her. She was immediately locked up on suspicion of poisoning Bill Taylor.

Within eight days of the funeral, Coroner Rendigs had the grave opened. Just as he suspected, Bill Taylor's stomach contained two and a half to three grains of arsenic, enough to kill several men, according to a *Cincinnati Post* report. "Rough on rats" was a composition of arsenic and strychnine. "The latter chemical would be rapidly assimilated with the system and only the arsenic would remain in the stomach to tell the tale," the article stated.

By noon on August 27, detectives figured they had enough evidence, along with Rankin's statement about buying the "rough on rats," to formally charge Liz with murder. She loudly protested her innocence and filled the "house of detention" where she was confined with intense lamentations. A *Cincinnati Post* reporter could not get her to talk with him.

Her companion in jail was a two-year-old boy. The child's mother, Belle Riss, filed a lawsuit against Big Liz in order to get her child back. Liz refused to return the child to his mother. Riss claimed she gave her son to Liz to board while she worked away from her home. She told the papers that she paid Liz $1.50 a week for her son's board. The boy's real name was Elmer Nelson, Riss said. A case was filed in court, but the outcome is not known.

Dressed in mourning and carrying a black-bordered handkerchief, Big Liz stepped before Judge William Shroder to be arraigned and said she was not guilty. The trial took place in November.

The evidence against Liz was largely circumstantial. She had threatened him in front of several people. Arsenic was found in Taylor's stomach, and witness Rankin claimed to have bought the "rough on rats" at her behest. It was noted that police failed to find "rough on rats" or the beer in her house.

During the trial, Taylor was described as a decent man. Even when he and Liz were on the outs, he would go to see their adopted child. (It is not known whether this was Belle Riss's child.) He would bring sweet treats and pennies to give the child. Liz had said he was a good provider.

Her attorney, E. Potter Dustin, provided the defense that Taylor was already sick the day before, and he produced witnesses to that effect. He also questioned the truthfulness of some of the women who testified for prosecutor Dan Wright.

Liz took the stand in her own defense. Her body filled the witness chair, which had been produced specifically to accommodate her girth. Huge tears rolled from her large brown eyes as she told the jury that all she gave "her husband" was a "generous draught of home-made blackberry cordial." She claimed that she herself drank some of it. The only other thing she did was put a hot poultice on his stomach. She denied any knowledge of the fatal dose of arsenic found in his stomach.

Hamilton County Courthouse. *Courtesy of the Public Library of Cincinnati and Hamilton County.*

The jury deliberated all that evening and into the next morning. After ten ballots, they came to a unanimous decision. The verdict was a surprise. She was guilty of murder in the first degree. Accustomed to her histrionics, the court expected her to make a scene when the verdict was announced, but she took it stoically.

Big Liz was the first woman in Hamilton County to be convicted of a capital offense. Other murderesses in the county had been convicted of manslaughter or second-degree murder and were sent to the penitentiary, but they had never been convicted of death-penalty crimes.

The public began to wonder if the state would hang a woman. Certainly, other women had been executed in the United States. In Ohio, Hester Foster had died at the end of a hangman's noose. But would it happen in Hamilton County?

Her weight alone could cause a problem. The drop from the trap would need to be six feet. There was a danger that the rope could snap under her weight and that the sudden jerk could decapitate her. *Cincinnati Post* readers wrote to the paper with their objections. "I don't think 'Big Liz' ought to hang. If she did poison Taylor she did it through devotion," wrote one *Post* reader.

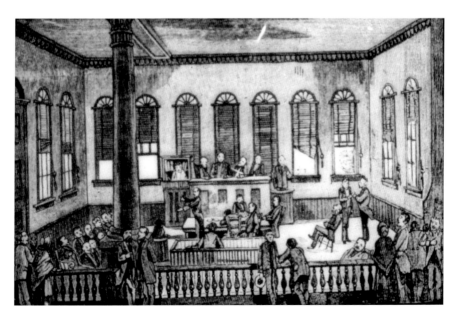

A courtroom in the Hamilton County Courthouse. *Courtesy of the Public Library of Cincinnati and Hamilton County.*

Beulah, another reader, wrote, "A woman ought never, under any circumstance be hanged by the neck….Conviction on circumstantial evidence ought not to send a man, much less a woman to the gallows."

Not long after the trial, one of the jurors, eighty-year-old William Stevenson, died. An article in the *Cincinnati Inquirer* said that "worry" over his misconduct during the trial hastened his death. Although he had seemed qualified and suitable to serve on the jury during voir dire, contrary to juror instructions from the court, he talked about the case. Affidavits of six men who overheard him were sworn and delivered to the court.

One of those affidavits alleged that he said in the barroom of the Keller House (where he was staying) that "Lizzie Carter sat up before the jury as brazen-faced as the devil." He also apparently said she should hang. With those affidavits, defense attorney Dustin filed a motion for a new trial. While Liz awaited Judge Shroder's decision, she was housed in the county jail. On January 1, 1891, the judge granted a new trial, citing misconduct of a juror.

Two days later, Liz got religion. She was one of five prisoners to receive the sacrament of Confirmation administered by the second Roman Catholic archbishop of Cincinnati, William Henry Elder. The newspaper said she was dressed in her finest.

Her second trial took place in March 1891 with a new jury of twelve men who knew nothing about the first trial and who were not opposed to the death penalty for a woman. This time, she was found guilty of second-degree murder. She would not hang, but she would spend the rest of her life in jail.

The *Cincinnati Enquirer* reported that when she heard the verdict of second-degree murder, she choked but said nothing. She was returned to Female Cell No. 4, which she shared with a woman named Effie McAllister. A while later, Effie pounded on the door of the cell to get attention from the watchmen. Liz had tried to commit suicide by swallowing a large amount of creosote given to her for a toothache, it apparently having anesthetic properties. She also took laudanum. She was writhing on the floor. With immense effort, the men loaded her into a patrol wagon and took her to the city hospital. Once released from the hospital, she was taken back to the Ohio Penitentiary.

In August 1892, Big Liz interrupted a fight between Mamie Scurry and Hazel Glen, two inmates in the women's department. The fight started over hanging laundry on the line. Mamie grabbed a rolling pin and started to beat Hazel to death. Liz pushed her weight between the two and hurled Mamie to the other side of the room, then ministered to the badly injured

Female Dep't. Wall, Ohio State Penitentiary, Columbus, Ohio.

The women's wall of the Ohio State Penitentiary. *Courtesy of the Columbus Metropolitan Library.*

Hazel. According to the *Xenia Daily Gazette*, Liz told Mamie, "You used a knife once, and that brought you here. It's what brought me here, too, and you should have sense enough to not talk of such things."

Mamie was removed to the "punishment room" and subjected to the "humming bird," which was an electric battery.

Big Liz never adjusted to jail. At one point before Christmas 1892, she was put in solitary confinement for thirteen days and given nothing but a bread-and-water diet. It was punishment for some infraction of the rules. Instead of taking the bread and water, she went on an eleven-day fast. At one point, she was so weak she could hardly sit up. Finally, she asked to talk to Warden James and told him she was sorry for her poor conduct and promised to behave. She was released from solitary and given poached eggs, toast and coffee.

She apparently did not learn her lesson, because in June 1894 she landed in solitary again. This time, she had threatened and attempted to assault other prisoners and matrons.

On February 10, 1898, Liz talked with a reporter for the *Cincinnati Post* about the possibility of being granted a parole when the State Board of Pardons met the next month. There was a petition signed by each of the jurors who convicted her saying that there was reasonable doubt of her

Ohio governor Asa S. Bushnell commuted Liz Carter's sentence. *Courtesy of Ohio History Connection.*

Ohio State Penitentiary warden Elijah G. Coffin. *Courtesy of the Columbus Metropolitan Library.*

guilt. In addition, the reporter had spoken with George Rankin, who testified that she sent him to buy "rough on rats." The reporter asked Rankin if he thought she was guilty, and he said, "No I cannot say that I do. I would feel a great deal better if Liz were out of prison. I want to say that I was not prejudice when I testified."

At first Liz did not want to talk with the reporter. She said she had given up all hope of leaving the prison walls. "I am not guilty," she said, "and it is awful for an innocent person to be shut up here."

"I am thirty-eight years old," she said. "I might as well be dead as to be shut up here for something that I never done."

Liz said Rankin never bought any rat poison for her. She said they never spoke to each other and that he did not like her. Rankin and Bill Taylor's sister had a child together. Rankin did not take care of his family, so one evening, Liz took the child to the Empire Ball, where Rankin was having a fine time. She placed the child in his lap, saying, "Here take your child and don't be ashamed of it." He was laughed at and left the hall. Ever since, he had it in for her, she said.

Three positions as a cook were available to Liz when she was released. She took the position offered by Michael Dolan, who was connected to the waterworks department.

As the reporter left the penitentiary, Liz said to him, "Say, if you put it in the paper, say that my name is Lizzie Carter, and not 'Big Liz,' and please see that it is spelled all right."

Bylines were seldom given to staff correspondents in most newspapers at that time. Curiously, this reporter's name appeared at the end of his piece. It was W.J. Taylor.

Upon the recommendation of the State Board of Pardons, Ohio governor Asa S. Bushnell commuted Liz's sentence on June 22, 1898. She was to be released immediately. Warden Elijah G. Coffin presented the papers to her. She wept as she took them from him. After seven years and six months, "Big Liz" Carter was free.

AXIS SALLY, WORLD WAR II TRAITOR

Mildred Gillars (1941–45)

Hello gang. Throw down those little ole guns and toddle on home. There's no getting the Germans down." During World War II, a sultry voice floated through the airwaves to homesick servicemen on the front. Behind those syrupy vocal chords was not the sexy, young girl of a GI's imagination but a bit-part actress of fading beauty who was past middle age.

Her name was Mildred Gillars, and she was an American. She called herself "Midge at the Mike," but the men and women who longed to hear Glenn Miller's swing music, Benny Goodman's clarinet and word from home called her "Axis Sally." As the highest-paid radio personality of the Reichs-Rundfunk-Gesellschaft German State Radio, Mildred broadcast Nazi propaganda from Berlin throughout Europe, North Africa and the United States from December 11, 1941, until May 5, 1945. Her program was called *Home Sweet Home*. It aired almost nightly from 8:00 p.m. to 2:00 a.m.

"I'm afraid you're yearning plenty for someone else," Mildred taunted homesick soldiers listening on their shortwave radios. "But I just wonder if she isn't running around with the 4-Fs way back home." Men classified as 4-F by the Selective Service were deemed unfit for the military for a variety of reasons, and men at the front were often resentful of those who dodged service.

Mildred Elizabeth was born to (Mary) Mae and Vincent Sisk on November 29, 1900, in Portland, Maine. Vincent, who worked for the railroad, was an abusive alcoholic and all-around poor husband and father. The marriage ended after seven years; Mae and Mildred never looked back.

A year after her divorce, Mae married Robert Bruce Gillars, a dentist who proved to be another alcoholic. Mildred's half sister, Edna Mae, was born in 1909. The family moved around in Canada and several states where Robert set up practice. Sometime in these years, Mildred took the last name of Gillars, although her stepfather never formally adopted her. Years later, Edna Mae told a reporter that Mildred and Gillars did not get along.

In 1914, the Gillars family moved to Bellevue, Ohio, and two years after that, they moved to Conneaut, Ohio. Although she was an average student with grades ranging from *B*s down to *D*s, Mildred fell in love with the theater at Conneaut High School. Her classmates remembered her as beautiful, with long black hair, deep brown eyes and dramatic flair in both actions and dress.

After graduating from high school in 1918, Mildred attended Ohio Wesleyan in Delaware, Ohio, and became active in plays with the Histrionic Club. If her first love was theater, Calvin "Kelly" Elliot was a close second. The two became inseparable and planned to marry. Instead of studying and attending classes, she spent her time sipping coffee and reading poetry with Kelly. Naturally, her grades suffered. Theater professor Charles M. Newcomb recommended she drop out of college and enroll in the Chronicle House, a drama school in Cleveland.

Mildred left Kelly behind and followed Newcomb's suggestion. The school gave her the opportunity to meet and act with well-known professionals. It also gave her more time to spend with Newcomb, a married man who left Ohio Wesleyan at the same time she did. Her job behind the jewelry counter at Halle Brothers Department Store barely paid her tuition and rent on a small room in a boardinghouse. Often there was nothing left over for food.

A year in Cleveland was enough for Mildred. She decided to follow her ambitions of becoming the next Theda Bera in New York. She succeeded in modeling for photographer Arnold Genthe and other artists. While she landed small parts in vaudeville shows and toured with acting companies, the big, meaty parts that would guarantee fame eluded her.

With Broadway and films out of her reach, Mildred decided to join thousands of other American expatriates in Europe. In the next few years, she made her way from France to Algiers to Dresden. Her mother, divorced from her dentist husband, joined her in 1934. They spent a happy month together in Hungary, then went to Berlin.

The window of opportunity was closing for Americans to leave Germany by this time. Mae was ready to go home and coaxed Mildred to go with her. But Mildred had found a job teaching English in Berlin at the Berliz School

Mildred Gillars posed for photographer Arnold Genthe. *Courtesy of the Library of Congress.*

of Languages, and she was in love again, this time with a German physicist named Paul Karlson. The two were engaged. Mildred told her mother that there was nothing left in the United States for her and that her life was with Paul. Mae went home alone. Mother and daughter never saw each other again. Mae died in 1947.

Paul went to fight on the eastern front and was killed. Mildred was left alone with no money. Not long after Paul's death, she accepted a job on German radio. When she needed her passport renewed, she went to the American State Department, but the vice council was aware that she worked for German radio. He snatched her passport from her and threw it in a drawer.

A short time later, she fell under the spell of Max Otto Koischwitz. Koischwitz was a German who had become a U.S. citizen while teaching German at Columbia University and German literature at Hunter College in New York. The Hunter College administration had put him on leave because he was openly supportive of Hitler and his lectures were full of anti-Semitic material. Koischwitz returned to Germany in 1940 to become a broadcaster as well as the program director for the German state radio, Reichs-Rundfunk-Gesellschaft.

She and Koischwitz began an illicit affair in spite of his wife and three children. He had such a hold over Mildred that she later said at her trial, "I believe that a man generally means more to a woman than anything else. I would have died for him."

Because Mildred spoke with an American accent, she was perfect to spread German propaganda to U.S. servicemen. Rita Zucca, an Italian American radio announcer, also broadcast Nazi propaganda and called herself "Axis Sally." But her home base was Italy.

Under Koischwitz's tutelage, Mildred became one of the best-known propaganda voices of World War II. Her messages were often anti-Semitic and anti-Roosevelt. "Damn Roosevelt! Dam Churchill! Dam all Jews who made this war possible. I love America, but I do not love Roosevelt and all his kike boyfriends."

GIs listened to Mildred's Axis Sally every night, but they mostly laughed off her propaganda. "Sally is a dandy—the sweetheart of the second AEF [American Expeditionary Forces]," wrote Corporal Edward Van Dyne in "No Other Gal Like Axis Sal" in the January 15, 1944 issue of the *Saturday Evening Post*. "She plays nothing but swing, and good swing!"

According to Richard Lucas in his 2010 biography *Axis Sally: The American Voice of Nazi Germany*, Mildred could get a hold of only so many records.

She, herself, got tired of playing the same ones over and over and figured the servicemen also wanted to hear new tunes. Her answer was to hire the band Dick and His Footwarmers to come into the studio and play the newest releases.

"Sally's goo is spiced neatly with little dabs of menace though. One of her favorite routines is to paint a warm, glowing picture of a little nest in the United States that might be yours; of the waiting wife, the little ones, the log fire," Van Dyne wrote. "You'll get back to all of that when the war's over." Sally would then hiss, "If you're still alive."

Sally was known to sign off in a seductive voice, saying, "I've got a heavy date waiting for me."

Mildred adapted the haunting "Lili Marlene" as her program's theme song. It was about a young soldier who would meet his sweetheart at night by lamplight at the barracks gate while he was on watch. At sunrise, he would have to leave her to report to roll call. It was one of the most popular wartime songs, particularly with German soldiers.

Mildred's broadcasts were heard by millions. American radios were tuned by the thousands to her programs. She often spoke directly to the women.

> *As you know, as time goes on, I think of you more and more. I can't seem to get you out of my head, you women in America, waiting for the one you have, waiting and weeping in the secrecy of your own room, thinking of a husband son or brother who is being sacrificed by Franklin D. Roosevelt—perishing on the fringes. Perishing, losing their lives and at best, coming home crippled—useless for the rest of their lives. For whom? For Franklin D. Roosevelt and Churchill and their Jewish cohorts?*

Mildred and Koischwitz visited hospitals and POW camps to record messages from injured or captured Americans to play for loved ones back home. The recordings were always edited, with Nazi propaganda inserted between the messages to make it seem as though the men were being treated well while being held prisoner. Some of the insertions made it seem like the GIs were sympathetic to the Nazis. She and Koischwitz collected names, serial numbers and hometowns to announce as "listener bait" before broadcasting the edited interviews. It came out at her trial that she sometimes posed as a Red Cross worker in order to get the men to talk.

Her most famous broadcast came in May 1944, shortly before D-day. She aired *Vision of Invasion*, a melodramatic play written for radio by Koischwizt. It was intended to further the Nazi cause and deter Americans

from invading France. Mildred played the role of an Ohio mother who had a premonition that her son, a soldier with the Allied forces, came to a terrible end during the invasion of Europe. The play predicted the total annihilation of American troops as they invaded France on D-day. The broadcast began: "Why D-day? D stands for doom, disaster, defeat and death!"

Koischwitz died of tuberculosis on August 31, 1944. Although she continued to broadcast, Mildred was devastated. Her voice lacked its usual spirit, and her programs became mediocre. She did, however, continue interviews of servicemen in German POW camps and hospitals.

Some of those men lived to testify at her treason trial. One prisoner of war, paratrooper Michael Evanick of New York, told the court that she came to visit him and sat down on an army cot across from him. She purposely sat with her legs apart so he could see she had nothing on under her skirt. She gave him cognac and cigarettes, hoping he would mellow enough to say that he was being treated well and that it felt good to be out of the fighting. Instead, he said, "I would rather be on the front lines where I got enough to eat."

GI Eugene McCarthy from Chicago testified that Mildred was accompanied by two German soldiers when she approached him for an interview. During her trial, he pointed to her from the witness stand. "She threatened us as she left—that American citizen! That woman right there! She told us we were the most ungrateful Americans she had ever met and we would regret this."

Another eyewitness said, "We called her a traitor and shouted names at her as she left the camp. She shouted vile names right back at us." On one occasion, servicemen gave her a carton of cigarettes packed with manure.

Mildred's last broadcast was on May 5, 1945, just two days before the Germans surrendered. The Russian army had entered Berlin. Having heard stories of how barbaric the Russians could be toward women prisoners, Mildred went underground, hoping to blend in with the rest of displaced people in Berlin. She traded or sold what few possessions she had for food. Going under the name Barbara Mome, she sold her furniture in antiques shops and secondhand stores. When her possessions were gone, she went hungry like thousands of others.

Once the Allies entered Berlin and stabilized the situation, Mildred came out of hiding, only to face an American soldier's gun. The United States had been monitoring her radio broadcasts, and the Counter Intelligence Corps had dispatched Special Agent Hans Wintzer to Berlin to track down Axis Sally. Posters with her photo were circulated throughout the city, and

she was soon found and arrested. She spent three weeks of 1946 in an American hospital, after which she was taken to an internment camp in Wansel, Germany. At the end of 1946, she was granted amnesty and released. She secured a pass to live in Berlin's French Zone. When the pass ran out, she went to Frankfurt to renew it. She was arrested there and held for more than a year.

In August 1948, she was flown to Washington, D.C., where she was held in jail without bond. She was indicted on ten counts of treason by a federal grand jury. The formal charges were printed in newspapers, including the *Richmond Time Dispatch*. The government claimed that Mildred Gillars "did from 1941–1945 unlawfully, willfully and treasonably adhere to the government of the German Reich, an enemy of the United States and did give to the said enemy aid and comfort." The charges were later reduced from ten to eight.

At the beginning of her trial, she seemed cool and detached. Newspapers described the forty-eight-year-old Mildred as wearing a tight-fitting black dress and spike heels to court each day. She wore her hair—no longer black but now gray—in shoulder-length curls. Her lips and nails were painted flaming red. Heavy makeup and rouge were layered over her face to hide the pallor from months in jail. A dramatic indigo scarf completed her ensemble.

Perhaps Judge Edward M. Curran had reason to recuse himself from the case—as assistant attorney general in 1943, he had signed an indictment against Koischwitz for treason, a charge that was later dropped, but he remained on the bench for Mildred's trial.

The prosecutor was Assistant Attorney General John M. Kelley Jr., known to be one of the best attorneys in the Justice Department. Lucas wrote that in Kelley's opening statement, he told the jury of seven men, five women and two alternates that Mildred had signed an oath of allegiance to the Nazis in exchange for celebrity. He said she became the mistress of Max Otto Koischwitz, a Nazi, knowing that he was married with three children and a fourth on the way.

According to Lucas's biography, Mildred's attorney, James Laughlin, bowed to her as she came into court and approached her seat at the defense table. Laughlin told the jury that Mildred had felt betrayed when President Roosevelt went back on his promise to keep the United States out of the war in Europe. He reminded the jurors that ten years earlier her feelings would have been in the mainstream. Laughlin explained that Mildred could not come back to the United States because she was broke and had no passport. He told them she was "in constant fear of life under the threat of

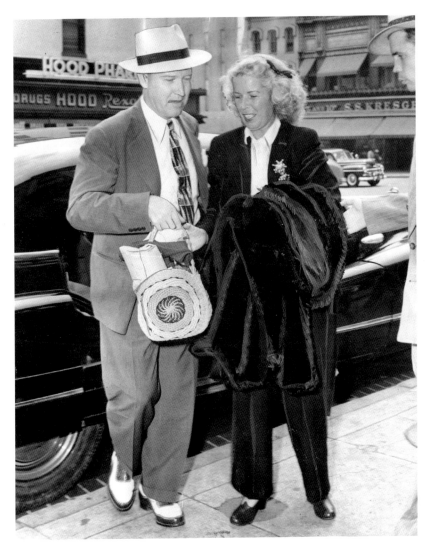

Mildred Gillars with an unknown man at the beginning of her trial. *Courtesy of* Washington Evening Star, *Washingtoniana Division, D.C. Public Library.*

the Gestapo." Lucas wrote that Laughlin called Kioschwitz a "Nazi cad" who preyed on Mildred's affections.

During the first week of the trial, the court heard Mildred's radio broadcasts. But first, to set the stage, the government played "Lili Marlene" on a turntable. After the musical introduction, twenty-nine acetate recordings of her broadcasts were played from beginning to end.

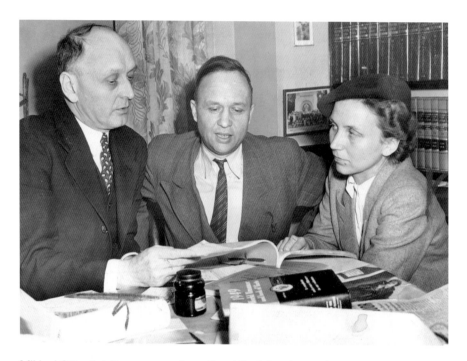

Mildred Gillars's defense attorney James Laughlin (*left*) and two others on her defense team. *Courtesy of* Washington Evening Star, *Washingtoniana Division, D.C. Public Library.*

The judge, jury and newsmen listened through headphones. The *Evening Star* reporter George Kennedy described how the jurors were also given transcripts of the broadcasts so they could follow along. Kennedy's article provided some of her quotes.

"So you want to sacrifice your sons to try to destroy that great country Germany," the silken voice of Axis Sally said. "It's the blackest page in the world's history. America should hang her head in shame."

Hayward H. Cook, a former serviceman in the Thirty-Fourth Division, came to court to finally set eyes on the woman he had listened to while on the front in Italy. A reporter lent him headphones so he could listen. "That's her all right," he said. "Sometimes she would tell you when you were going to make the attack—she'd know before you would—and make you dread that." Biographer Lucas pointed out that her broadcasts had been searched, and she never revealed military units or bases. Cook told the reporter that the airmen would drop records addressed to Sally over Germany and ask her to play them.

Next, a procession of former prisoners of war and injured veterans took the stand to tell of meeting her. Each remembered that she claimed to be

with the Red Cross. One said she wore a Red Cross pin. A couple of the men remembered calling her the "Berlin Bitch."

Lucas wrote that on the day Mildred took the stand, she was dressed in a green sweater, tan jacket and black skirt. Her hair was swept up. Laughlin led her through her childhood and college days. She told of her time in Cleveland and New York and finally in Europe. Throughout her adult life, she was constantly penniless, constantly in search of a way to make a living, constantly looking for stability. She said she finally found stable employment on German radio.

Mildred told the jury that after the Pearl Harbor bombing, she was terribly upset and made her feelings known at the radio station. Because Germany was part of the Axis Alliance, her angry outburst put her in danger. The station manager, Johannes Schmidt-Hansen, ordered her to swear her allegiance to Germany or she would lose her job. Erwin Christiani, her friend at the radio station, drew up an oath. The forty-eight-year-old spinster claimed she signed it in "order to live." Laughlin claimed that the "oath" meant she could still eat and have a roof over her head. When Christiani was called to the stand, he

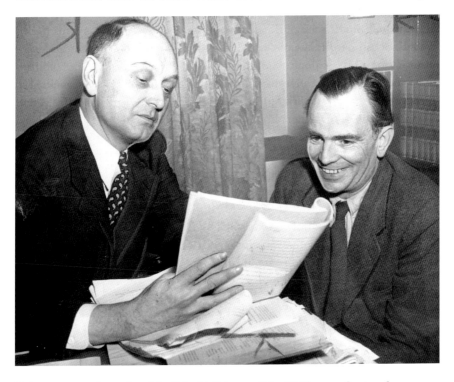

Defense attorney James Laughlin (*left*) with Johannes Schmidt-Hansen. *Courtesy of Washington Evening Star, Washingtoniana Division, D.C. Public Library.*

backed up her story. Laughlin asked Christiani if Mildred could have stopped broadcasting for German radio. Christiani said, "No."

Laughlin tried to gain sympathy for Mildred by capitalizing on the hold that Koischwitz had had over her. But she was her own worst enemy and refused to answer his questions about their love affair. Finally, she blurted out that she considered Koischwitz to be her "destiny."

Mildred's biggest mistake came when she testified that she knew Koischwitz was connected to Joachim von Ribbentrop, the foreign minister of Nazi Germany. Throughout the trial, Laughlin had tried to distance her from any of Hitler's administration. He was stunned when she revealed that the man she loved was closely tied to the regime.

Under cross-examination, she admitted using anti-Semitic words like "Jew" in a derogatory way and "kike" "quite a lot." She denied presenting herself as a Red Cross worker or exposing herself to a prisoner of war or threatening any of the men. She described the prison camps as "picturesque."

Mildred was clearly exhausted by the end of her trial—she even fainted once. Her cool exterior cracked periodically, and she was tearful at times on the stand, but she remained evasive and unapologetic for her love of Koischwitz.

Late on the second day of jury deliberation, the twelve jurors filed into the courtroom with their verdict. Mildred was guilty of only one of the eight counts that the government brought against her. Out of all the broadcasts the jurors had heard during the trial, they chose *Vision of Invasion* on which to convict her.

Mildred was defiant at sentencing. She argued with Judge Curran, saying *Vision of Invasion* was written by Koischwitz, who was indicted in absentia in 1943 for treason. Four years later, he was exonerated for lack of evidence. She contended that she should also be exonerated for her part in the script. The judge cut her off and sentenced her to not less than ten years and not more than thirty years at the Federal Reformatory for Women at Alderson, West Virginia, and fined her $10,000. She took the sentence with her "chin held high and no other outward show of emotion," James J. Cullinane of the *Evening Star* wrote.

It took Mildred some time to adjust to prison life. At first, she was sullen and preferred to be by herself. She even refused to see her sister, Edna Mae, who had stood by her throughout the trial. In time, she found ceramics to be enjoyable and crafted blue Bavarian beer steins that were etched in German with the motto "Accept your fate for it is sealed." She directed both the Protestant and Catholic choirs at the prison.

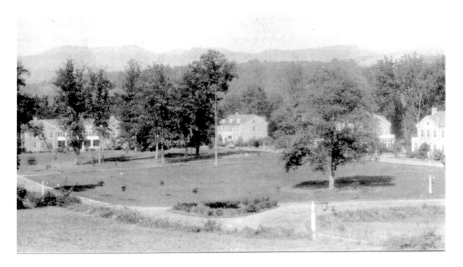

Alderson Prison, Alderson, West Virginia. *Courtesy of the Greenbrier (WV) Historical Society.*

Mildred Gillars leaving Alderson Prison. *Courtesy of* Washington Evening Star, *Washingtoniana Division, D.C. Public Library.*

Eligible for parole in 1959, she chose to pass up the opportunity. One can only guess her reasoning. Perhaps she was not ready to face a public who hated her, or maybe she did not have a job. Lucas suggested there was talk of sending her back to Germany.

She applied for parole a year later and was turned down, because she had no job waiting. Later that year, she converted to Catholicism; the prison chaplain, Father Thomas Kerrigan, helped her find employment at Our Lady of Bethlehem School near Columbus, Ohio. Her parole was approved on January 12, 1961. After serving twelve years, she was released on July 10 under the condition she meet with her parole officer every two weeks for the next eighteen years.

Mildred's sister, Edna Mae Herrick. *Courtesy of* Washington Evening Star, *Washingtoniana Division, D.C. Public Library*.

On the day she walked out of Alderson, she was met by twenty journalists and photographers. Although she declined to say anything of substance to the reporters, she seemed to enjoy the cameras. An article in the *Evening Star* said that "she strode out of prison with the flourish of an actress." Her half sister, Edna Mae, who was then married to Edwin Niemensen, was there to take her to Ashtabula to stay until school started in Columbus. While at her sister's home, a Catholic family took her to Mass and invited her to dinner.

After Labor Day, she moved to Columbus and never saw Edna Mae again. Mildred taught music, drama and English and German for thirty dollars a month. She lived a simple, quiet life on the north side of Columbus at the convent of the Order of the Poor Child Jesus with the nuns that operated the school.

Fifty years after leaving college, she returned to Ohio Wesleyan to finish her bachelor of arts in English and oratory. She was seventy-two years old when she was handed her diploma.

At the age of eighty-seven, Mildred Elizabeth Gillars, aka Axis Sally, died at 3:00 a.m. on June 25, 1988, of colon cancer. She was penniless most of her life, and she remained so in death. She was buried as a charity case in an unmarked grave in St. Joseph's Cemetery in Columbus.

An older Mildred Gillars, possibly during her teaching years. *Courtesy of* Washington Evening Star, *Washingtoniana Division, D.C. Public Library.*

THE MADAMS OF OTTAWA COUNTY

Rose Pasco and Lillian Pasco Tailford Belt (1930–71)

Rose and Lillian "Ginger" Pasco were two of the most notorious but fondly remembered madams from the northwestern part of the state. Rosie ran houses of ill repute and hosted wild parties at different places around Port Clinton in the 1930s and '40s. She was Lillian's mother-in-law. Lillian—or Ginger, as she was often called—did not get into the trade until later, when she ran the Round the Clock Grille just five miles outside of Genoa. Later, the feds came looking for her for failure to pay all of her taxes and for transporting women across state lines. In addition to prostitution, Rosie and Ginger got caught up in a bribery case in 1970 that brought down a sheriff and a former sheriff.

Rosie came to Cleveland from Plainfield, New Jersey, with two sons and a daughter sometime before 1929. The clues as to why she made the change are long buried, as is any information on James Pasco, the father of her children. In October 1929, she married Raymond K. Sherry, a barber, who lived on Eighteenth Street in Cleveland. She lived on Euclid Avenue at the time. Her name on the marriage certificate is Rosie Shallo, but that could be because her maiden name was Sciallo, which was probably pronounced "Shallo." She was born to parents Michael and Mary on February 18, 1900. Rosie claimed on the certificate that this was her first marriage.

By the next year, Rosie and her husband had moved to Monroe Street in Port Clinton. Not long after moving to Ottawa County, she began making a name for herself with the county's men as a first-class madam. Some newspapers called her "Dago Rose"—she hated that term.

Her troubles with the law came to a head when she threw a raucous party on a Saturday night in the summer of 1930 at an Ascher Beach cottage, where she had been operating for a number of months. Ottawa County deputy Dewey Cullensen got wind of the festivities and was determined to put an end to them. He told the *Ottawa County News* that when he and the other deputies got to the cottage, the door was bolted. He banged on the door. Everything in the house went quiet, and no one answered. He saw a face in the window then heard a second bolt sliding into the door jamb. By now, he was thinking the revelers inside had been tipped off.

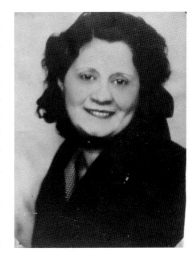

Rosie Pasco was a notorious madam in Ottawa County. *Courtesy of Mike Tailford.*

The screen door was latched, so he ripped it off its hinges. With the help of his deputies, he battered down the heavy wooden door. As the door flew open, Cullensen saw about two dozen men scramble to escape or otherwise hide themselves. He later said, "The majority of the men never did, and probably never will, move so fast in their lives."

The deputies rounded up the men and found most of them were from Port Clinton, some single and some married. They came up with a number of stories as to why they were there. Some claimed to be there as repairmen. Others said they were just passing by and thought the cottage was on fire, so they stopped to investigate. Cullensen said the best story came from a man who claimed to have left his hat and coat there a few days earlier and had just gone back to fetch them. When the police stormed the house, the guy ran across the field, leaving his hat and coat behind.

It was during Prohibition, so the authorities were on the lookout for alcohol as well as prostitution. Although Cullensen did not find any liquor, he suspected the attendees had been drinking, as there was a strong smell of alcohol in the air. He figured a bottle had been broken into a pail just before he and his officers burst through the door.

Deputies questioned the men at the party, took their names and released them without charges. Rosie and one of her girls, Helen Ryan, were not so lucky. They were hauled off to the Ottawa County jail and locked up until the following Monday morning, when they faced Justice of the Peace John J. Robinson. Rosie pleaded guilty to running a house of prostitution and

was fined $300.00. She was sentenced to ninety days in jail, but Robinson suspended her jail time if she promised to clear out of the county within ten days. She promised she would. Rosie paid court costs of $8.66.

Helen Ryan, who gave her age as twenty-six and her home as Toledo, got pretty much the same treatment from Robinson, except she had no fine and was told to vacate the county within forty-eight hours. She left town the next morning.

Rosie broke her promise and reopened Rosie's Place off Route 2, two miles east of Port Clinton. This put her in proximity to Camp Perry. Her brothel was so popular with the men from the base that the Ohio National Guard posted guards at the roadside entrance to her house to dissuade servicemen clients. Even that did not keep soldiers from patronizing Rosie and her "erring sisters." Her reputation was growing. Men from every corner of Ohio and several surrounding states heard about her. She was also becoming known for her generosity to anyone in need.

By 1934, Rosie had repeatedly been warned to close down, but, as one reporter from the *Ottawa County News* wrote, "Dago Rose Sherry apparently thumbed her nose at the order, and continued to keep the house open."

Cullensen had become sheriff of Ottawa County by this time. The National Guard considered Rosie a nuisance and asked Cullensen for assistance in closing down her cathouse. Vowing to "clean her out," Cullensen and National Guard officials raided Rosie's on Friday night, July 27, 1934. They immediately arrested three of the girls. Rosie was nowhere in sight, but after hunting around, they found her hiding in the bushes a distance away from the house.

Rosie and her girls were told to leave the house and not return. The men who were caught in the house were booted out, and Cullensen locked the place up. The "clients" were told to "get out and stay out."

No arrests were made in that incident, and Rosie was allowed to go back the next day to retrieve some personal items. A few weeks later, she had reopened for business.

A one-paragraph story in the May 9, 1941 *Sandusky Register* was evidence that not all of Rosie's customers were friendly. Five men attempted a holdup at her house but "were driven away before any loot was secured." Two of the thugs had shotguns. One of the guns was dropped as the men made their escape in an automobile. Sheriff Ralph Riedmaier found no clues as to who the perpetrators were.

On May 15, 1942, authorities moved in again on Rosie's Place as well as another house operated by Faye Clark. This raid netted six arrests for

Sheriff Riedmaier and Deputy Harry Swartzlander. Besides Rosie and Faye, Anne Brown, Raye Rogers, Francis Rogers and Georgia Brown were rounded up. Rosie and Faye were given ninety-day sentences. The sentences were suspended provided they quit the business. Both were fined $100. The other four women each served ten days of ninety-day sentences and were let go after passing health examinations.

After that, Rosie moved south to Fremont in Sandusky County, where she set up shop on Wabash Avenue. City leaders there did not want her kind of business any more than Port Clinton's had. For one thing, a sailor from Great Lakes, Illinois, contracted a communicable disease while patronizing Rose's establishment. In the fall of 1945, the Fremont City Board of Health set forth an order that prostitution, regulated or nonregulated, would not be allowed in the city.

The following April, authorities decided to take a different tack to put Rosie and her ilk out of business. This time, they would get the federal authorities involved. The county health commissioner, Dr. George A. Poe, teamed up with Walter A. Hixenbaugh, who was on loan to the Ohio Health Department from the Federal Security Agency.

Fremont police chief Charles Johnson was aware of Rosie's house of ill repute and had been checking on it for some time, but he said the inhabitants were cautious to steer clear of police intervention.

On April 30, Rosie let her guard down. Authorities descended on the house and arrested her and her girls. Dr. Poe planned to hold the women in jail without bond until they could be examined for health issues. He said if they returned to the house on Wabash Avenue and stayed for more than twenty-four hours, they would be rearrested and held for another ten days and another health exam. He instructed authorities to keep this up until the girls left the county. While that house was shut down, Rosie would continue her career as a madam for years to come.

Anecdotes abound about Rosie, according to Phoebe Borman of Port Clinton. A frequent story has it that Rose dodged police intervention by wrapping money in newspaper and leaving it on the porch for authorities. Another tale had to do with a bunch of high school boys piling into a car and driving up to Rosie's house. She refused them because they were not adults. She had her standards.

One of her houses was on Buckeye Boulevard on the outskirts of town. John Pointer grew up in Port Clinton and remembers seeing Rosie's house for the first time when a co-worker coaxed him into having a look. Pointer, who was eighteen at the time, had cut his hand at the factory where he

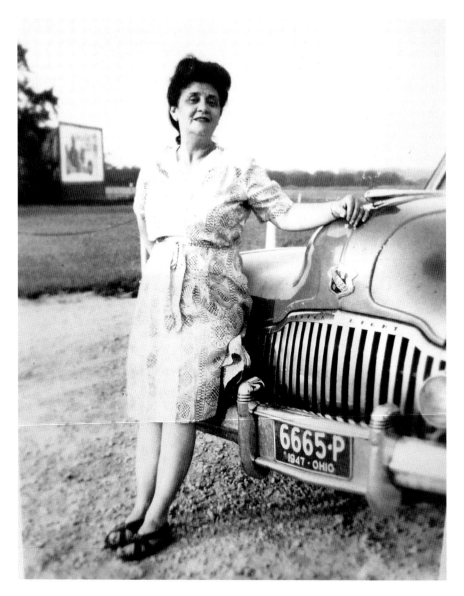

Rosie Pasco, proprietor of a brothel in Port Clinton, was also known for her generosity. *Courtesy of Mike Tailford.*

worked. His boss had an older worker take him to get stitches. Leaving the hospital, "my co-worker who was from Toledo asked if I knew where Rosie's whorehouse was located," Pointer said. He had a general idea and directed his co-worker which way to turn. When they got to the house,

they pulled into the long, gravel driveway. It was a two-story, white, wood-sided house with a small porch on the driveway side. "As we got close to the building I noticed a red hose stretched across the driveway." He said it was like the ones in gas stations that rang a bell, letting the attendant know someone was at the pumps. As they drove over it, they heard the ding, ding of the bell. "In a few seconds, a nicely dressed older woman opened the door and looked out."

Pointer went on, "My buddy asked if I wanted to come in." Pointer declined and waited in the car. His co-worker came back out in ten minutes and told him, "There were seven beautiful women sitting around the table eating supper." His friend managed to find out what the prices were.

Port Clinton's teenage boys knew about Rosie's. Older brothers told younger brothers, and friends told friends. "Back in the woods, or in the tree fort, smoking cigs that one of you snuck out of a pack of your parents'," said Pointer. "You told each other the latest about sex stories you had heard. Rosie's would come up from time to time."

Pointer was curious about Rosie, but not curious enough to ever visit her house. He asked his father if he knew about Rosie's house. It turned out that Rosie bought her produce from his father's store. "Dad said she was a very kind woman who never had a bad word about anyone. She donated to the Catholic Church and to help the poor." His father told him Rosie sent holiday baskets to the less fortunate and helped people in need. "Mind you, she never once bragged or said anything about these deeds."

Borman said that any charity could knock on Rosie's door and she would donate.

In 1955, her elder son, Michael, died of an enlarged heart. His obituary called it a lingering illness. He left behind his mother; his brother, Nicholas; his sister, Janet; and his wife, Lillian. No children were listed in the obituary.

Michael was Lillian's third husband, according to her son, Mike Tailford. One of the earlier husbands was a sailor named Bud, whom she married in 1942. The other's name has been lost in time.

Lillian Joan Lewandowski had grown up in Toledo on Humboldt Street with her mother, stepfather, four sisters and one brother. Her birth father committed suicide. A small photo of Lillian in her sophomore year at Central Catholic High School showed her to be blond and wearing glasses. (Mike Tailford said she changed her hair color from time to time but was most often a redhead—so she was called Ginger.) Lillian left home at fifteen and went to Florida, where she lied about her age to get a job painting signs.

From left to right: Joseph "Holy Joe" D'Angelo, Mike Pasco, Lillian "Ginger" Pasco and Nancy Maxwell at dinner in Miami, Florida. *Courtesy of Mike Tailford.*

After Michael's death, Lillian—or Ginger—was free to take up residence in Fostoria with a new man by the name of George Tailford Jr., a.k.a. Lewis Tailford Jr., a.k.a. George Lewis. She and Tailford were married and divorced twice. In 1956, the pair took a trip to Michigan, where they visited the Sunshine Gardens nudist camp in Bedford Township on the western edge of Battle Creek. The camp did not keep records, so it is not known whether Ginger and Lewis Tailford were regulars.

The Michigan State Police raided the camp on June 15 and arrested Ginger and Lewis Tailford and John Kroupa of Independence, Ohio. State police detective Ray Whalen said he saw the three in the nude when he visited the camp. All three were charged with indecent exposure. Kroupa pleaded guilty and paid his fine. Ginger and Tailford were released under $500 bond and went back to Fostoria. Ginger tried to fight extradition to Michigan to no avail. A couple of months later, she and Lewis Tailford appeared in circuit court in Battle Creek and paid $200 in fines.

In the 1950s and early '60s, Lillian had been running the Round the Clock Grille at the corner of Woodville and Fostoria roads. Ginger's son,

The Round the Clock Grill served food downstairs. Upstairs was a well-known, well-attended bordello run by Ginger Pasco Tailford. *Courtesy of Mike Tailford.*

Mike Tailford, said his mother drove a 1951 red-and-white Eldorado. She was somewhat vain and meticulous in her dress. "She had sunglasses that matched every outfit," he said.

Lou Hebert of Toledo wrote about the "Clock" in both the *Press* and on his blog, *The Toledo Gazette*. Both articles brought out comments from citizens who had known Ginger.

Although Hebert was young at the time, he remembered the two-story building with the large neon clock because he delivered groceries there and to Ginger's large, gated Californian-style ranch house near Elmore. The Clock was a restaurant downstairs that apparently served good food. The back stairs led up to the bordello. When the luminous red hands on the clock were running, it was a sign that the upstairs was open for business. The Clock was a favorite for soldiers either leaving for or coming home from Vietnam. On any given night, the parking lot was full of waiting taxicabs, semi trucks and cars belonging to Toledo men. It was one of the best-known brothels in northwestern Ohio and southeastern Michigan. Everyone for miles around knew what went on at the Clock, but it ran for years without police interference.

Posts left on Hebert's blog included fond memories of the women who worked at the Clock.

According to a former inmate who left a post on Hebert's blog, the girls were healthy and were checked by a doctor once a week. "There were 6 or 7 girls there day & night. We were like one big happy family!!...It was a great place with great people!!" She had worked at the Clock for four or five years. She also worked for Rosie.

In 1963, the feds started to look at Ginger. Her attorney told her that if she wanted to keep her two adopted children (Michael and Tamara), she should get as far away from Port Clinton as possible. She chose Arizona and moved to Phoenix in 1963. According to Mike Tailford, Nancy Maxwell and her husband, Joseph "Holy Joe" D'Angelo, owned the building and continued to manage the Clock.

Ginger met Richard G. Belt, a bartender, sometime after leaving Ohio. The two were married in Las Vegas in January 1966. They lived in Phoenix. Mary Leonhard, the "Sun Living" editor of the *Arizona Republic*, wrote about Lillian's new home in August 1968. "Mr. and Mrs. Richard G. Belt didn't buy their house and its 1½ acre desert plot on N. 38th Place. Its former owner traded it, plus an airplane and a boat for their former home on Morning Glory Lane." Leonhard gushed about the five bars, three waterfalls and two stone fireplaces. "A hole had to be cut in the master bedroom to install its pink quartz fireplace."

The article mentioned their four dogs, two monkeys, six birds, one hundred fish in seven aquariums and the two children, who attended boarding school. The article featured a photo spread of rooms in the house and a portrait of Ginger and Richard seated by the pool. Clearly, Ginger was basking in luxury.

Mike Tailford remembered the parties his mother threw. "She loved to throw parties and then she was the life of the party." One of her best parties was for a whole pro sports team. And she had lots of friends, one of whom was Amanda Blake, "Miss Kitty" from the TV program *Gunsmoke*. Her friends remembered her as kind and giving.

And money was no option when it came to Ginger's children. Her son remembers wearing little three-piece outfits as a very small child—no jeans with holes in the knees for Ginger's children. It was a life of extravagance, Mike related.

But it would all come to an end when federal investigators started looking at her connection to the Round-the-Clock and the Internal Revenue Service got interested in her taxes. It was suggested that the article showcasing her lavish lifestyle is what caught the IRS's attention.

Lillian "Ginger" Pasco-Tailford-Belt was the proprietor of the Round the Clock Grill. *Courtesy of Mike Tailford.*

A federal task force consisting of the FBI; IRS; the Alcohol, Tobacco and Firearms division of the Treasury Department; and the U.S. Marshal's Office swooped in on the Round the Clock on January 21, 1970. The twenty to twenty-five agents were armed with search warrants and subpoenas. Assistant U.S. attorneys William Connelly and Peter Handwork told news reporters that the move was "part of a continuing investigation into organized crime in northern Ohio conducted by the U.S. Attorney's office and the Cleveland-based federal task force on organized crime."

Assistant U.S. Attorney Peter Handwork. *Courtesy of the Toledo Lucas County Public Library*.

Nancy Maxwell and Joe D'Angelo were near the top of at least thirty-five subpoenas. Rosie's name appeared on one of them. Cab drivers for three companies were subpoenaed. Subpoenas were also handed out to Port Clinton city officials, including the mayor, safety service director, police chief, city solicitor and county prosecutor. And Lillian's name was on top of the pile.

Nancy Maxwell's attorney, who did not want his name known, spoke with one of the agents and asked for the basis of the warrants. The agent said they were based on a section of the law prohibiting transportation across state lines for illegal purposes. The violations covered such crimes as liquor, narcotics, gambling, extortion, bribery and prostitution. Those who were served were to tell what they knew about the Clock to a federal grand jury convened in Toledo on February 2, 1970. One of the cab drivers testified that his trips to the Clock were particularly profitable, often netting large tips from both the passenger and the house.

Ginger was arrested by U.S. Marshals in Phoenix. She fought extradition; a Maricopa, Arizona judge ruled that she did not need to return to Ohio, citing the distance. She testified at a hearing in front of the judge that she had lived in Arizona since 1963 and never left the state during 1969. Three witnesses wrote letters supporting her claim. She was released on $22,000 bond.

The *Arizona Republic* reported that the grand jury in Ohio found evidence that she willfully evaded paying $46,443 in income taxes during a two-year

period. The IRS claimed she reported taxable income of $14,530 with taxes of $4,509 in 1963 and that she should have reported $55,510 in income and taxes of $30,952. In 1964, she reported an income of $15,068 with taxes of $3,738; her income was actually $49,900 and her taxes should have been $23,738. She was further accused of eight counts of interstate transportation of prostitutes. The article also recalled the previous feature describing Lillian's palatial home.

By March, the investigation had widened to include Ottawa County sheriff James C. Ellenberger, two of his deputies and several members of the Port Clinton Police Department. They were summoned before a second federal grand jury in Toledo. Three more indictments came out of that hearing. Ellenberger, former sheriff Myron Hetrick and Kenneth "Red" Brewer, a vending machine operator, were all indicted for perjury in connection with the probe into the Round the Clock.

During the previous hearings on prostitution payoffs, the three had repeatedly denied receiving or distributing funds during their testimony. Hetrick and Brewer were arraigned and let loose on $5,000 bond each. Ellenberger, who was in the hospital during the hearing, denied receiving in excess of $13,800 in 1969 "from a source known to him, and also distributed certain funds to certain deputies on his staff in the form of Christmas bonuses or other gifts," according to Assistant U.S. Attorney William Connelly. Ellenberger was arraigned upon release from the hospital and freed on $5,000 bond. Brewer, who worked for the Peninsula Candy Company, was alleged to have been the contact between the sheriff and the Clock.

Ellenberger resigned his position as sheriff at the beginning of April. A few months later, he pleaded guilty to perjury in the Federal District Court of Northern Ohio. He made restitution of nearly $14,000 and received a suspended sentence. Hetrick also pleaded guilty and was sentenced to five years in prison

"It's about time," some of the locals told a *Toledo Blade* staff writer. For years, local citizens knew about the Clock and Rosie's Place on Route 2 at Port Clinton's edge and were hard put to understand why something had not been done earlier. They got their answer when they found out that two sheriffs had been indicted and convicted. Some of the neighbors were shocked—not that the place had been raided, but that it had not been raided sooner.

A neighbor whose home was adjacent to Rosie's Place told the *News Herald* that there were so many visitors to the brothel that they had to put a sign in their yard that read "KEEP OUT THIS IS NOT ROSIE'S." Each night,

the sign got knocked down. "I think it is about time they do something. I have three boys growing up," the mother said. "When my children ask me if this sort of thing is wrong, and I tell them it is, they ask me why someone doesn't do something about it."

Rosie hired Toledo attorney Gerald Lubitsky to defend her against ten counts of keeping a house of prostitution and ten counts of bribery over a period of ten months in 1969. She was also fighting off two counts of perjury. Lubitsky asked the court to demand a list of the men who visited her house and their addresses. He said that Ottawa County prosecutor Lowell Petersen was intentionally discriminating against Rose Pasco by enforcing laws against her but not against others who had violated the same laws.

Lubitsky wanted Petersen to make known whether Rosie herself had committed acts of prostitution, and he also wanted Petersen to submit a list of names and addresses of men who visited Rosie's establishment.

Next, Lubitsky wanted to depose Ellenberger, who was listed as a witness for the prosecution. He wanted a bill of particulars (a detailed statement on the charges) saying she gave the former sheriff $1,000 a month to "influence his performance as a sheriff." He also asked for the makes, models and serial numbers of the refrigerator and television she allegedly gave Sheriff Riedmaier. During her testimony before the grand jury, she said she had not given him a refrigerator or a television.

Petersen filed four bills of particular. One charged that the payments alleged to have been made to Ellenberger were for the purpose of him turning a blind eye to the Clock and Rosie's. The second bill charged that Rosie contributed to a portion of the $13,800 Ellenberger received. The third bill of particulars stated that Maxine Scott and Lillian Belt made payments through Kenneth "Red" Brewer, who was acting for his employer, Frederick Johnson. The fourth bill named the payments to Ellenberger.

Petersen's case was weakened when he was forced to throw out one of the perjury charges. Subpoenas for Ralph Riedmaier, Merlan Budd, Myron Hetrick and Rosie's daughter and son-in-law were suppressed. The five refused to testify and would claim the Fifth Amendment privilege if forced to get on the witness stand. Petersen finally dropped charges against Rosie and Nancy Maxwell. In the end, only Brewer was found guilty—on two counts of bribery—and was put on probation.

In subsequent proceedings, Nancy Maxwell and "Holy Joe" D'Angelo pleaded guilty to charges of aiding and abetting interstate transportation for the illegal purpose of prostitution. She was sentenced to three years in a federal penitentiary. He was given probation.

Toledo Courthouse, United States District Court, Northern District of Ohio. *Courtesy of the Toledo Lucas County Public Library.*

Rose Pasco's final resting place at Riverview Cemetery, Port Clinton. *Photo by Debbie Gibson.*

In January 1971, Ginger was returned to Ohio to face charges of tax evasion and aiding and abetting illegal interstate transportation of prostitutes in U.S. District Court in Toledo. She pleaded guilty to income tax evasion and admitted running a house of prostitution. She was sentenced to four years in the Federal Reformatory for Women at Alderson in West Virginia, and she agreed to pay back taxes of $120,000 once she was released.

Ginger served out her prison sentence and returned to a quiet life in Phoenix, first working at a furniture store until cataracts took her eyesight. After surgery to restore her sight, social services helped her get training to become a respiratory therapy technician.

Her name appeared in the *Arizona Republic* in November 1999 when her daughter Tamara Lillian died, and once more ten years later when she herself died of chronic obstructive pulmonary disease (COPD) at the age of eighty-nine.

In remembering his mother, Mike Tailford said, "She was a good, loving mom to us."

Rosie went into business with her daughter and son-in-law when they bought the Sun Valley Golf and Country Club in 1976.

Rose Pasco died of heart disease in 1979. Her funeral Mass was held at Immaculate Conception Catholic Church. She was buried in Riverview Cemetery in Port Clinton.

THE DEVIL PUT ME UP TO IT

Martha Wise (1925)

"Won't somebody tell me why I did it?" sobbed Martha Wise through her jail cell bars. The forty-one-year-old widow had slipped rat poison into the water pails at both her mother's and her uncle's houses and gotten caught. Three family members died. Thirteen others, including children, were seriously afflicted.

"The devil made me. The devil made me," she confessed to a jail matron.

Martha lived in Hardscrabble, a Medina County village at the corner of Columbia and Grafton roads. She was a peaked little woman with dark, deep-set eyes. Her mouth was a thin line turned down at the corners, perhaps owing to the grind of her life.

Her reason for poisoning her family was never really established. Chroniclers and gossip laid her killer deeds to her peculiar hobby. She loved to go to funerals and would walk up to twenty miles to attend one, whether or not she was close to the departed or the bereaved. Perhaps enough people were not dying in Medina to satisfy her ghoulish pastime, so she thought she would contribute to the funerals.

The law had a second theory. Martha had fallen in love with a Cleveland man named Walter Johns and wanted to marry him. Whether he wanted to marry her was another question. She was anything but a good catch. She was a broken-down woman, and every year of her life showed on her face. She was not very smart. She had no money, and she was raising four children on her own.

When her family caught wind of her flame, they forbade her to see him. Her mother, Sophie Hasel, was most uncompromising. She was the first to die. The seventy-two-year-old woman and two others fell ill with a severe stomach ailment on Thanksgiving Day 1924. The older woman languished in pain until December 13, when she died.

On January 1, 1925, Martha's uncle Fred Gienke, his wife, Lilly, and their children all became ill with similar symptoms. Martha was at the house with the family and appeared to be sick. At first, the physician, Dr. Wood, thought it was ptomaine poisoning or possibly botulism from a meal of leftover pork and vegetables boiled in an aluminum pan. But as the doctor started to treat the patients, he realized it was more than food poisoning and called in another doctor for a second opinion. Martha was the first to get back on her feet. As the hours wore on, the children and Fred began to recover. Lilly was not so lucky. She died three days later.

According to a 1954 article in the *Akron Beacon Journal* that recapped the case, the doctors went back to the house for a look around. While there, they took notice of the coffee pot. One of the doctors allegedly smelled arsenic in the pot. The physicians notified coroner E.L. Crum and the Medina County health commissioner, Dr. H.H. Briggs, but the two officials did not feel there was sufficient evidence to warrant an investigation.

After Lilly's funeral, Fred tried to get the blue-and-white coffee pot and the coffee grounds, which were still in it, analyzed in Cleveland. "I'm certain it was the coffee," Fred said, adding that he would pay to have it analyzed. "To satisfy myself, at least, that the trouble was there." The Cleveland lab refused to have a look, because the evidence was not from Cuyahoga County.

Within the next few weeks, a number of the Gienkes, including Fred, had another attack. The symptoms were the same—constant stomach pains and stiffening leg muscles. Fred and two of his children, Marie and Rudolph, became so sick that they were taken to the Elyria hospital. This time, Dr. Briggs took blood samples from the victims and water samples from the house and sent them off to the state health department. But it was a dead end. The analysis showed nothing.

Then Fred died on February 6. A postmortem showed an inflamed stomach.

Three of the Gienke boys recovered, but Fred Jr. was still gravely ill. Twenty-six-year-old Marie and seventeen-year-old Rudolph were both paralyzed to varying degrees. Since blood samples gave no clue as to the perplexing illness, doctors took urine and feces specimens from Marie and Rudolph for analysis. Those tests came back showing arsenic poisoning.

The information was turned over to Sheriff Fred O. Roshon and prosecutor Joseph A. Seymour.

The authorities kept the investigation quiet for a month, but then Roshon uncovered where the arsenic had been purchased. Martha Wise, niece of Fred and Lilly and cousin to their children, had signed the registry for two grains of arsenic at Wall's drugstore in Medina. A week later, she purchased one grain. Her signatures were barely legible. The second signature looked as if she had tried to disguise her writing. The dates on the registry matched up with the deaths. According to the *Medina Gazette*, Seymour had reservations. "It is hardly enough to say that this person obtained the poison for a murderous purpose," he said. "It merely was in the range of possibility."

Clues may have been falling into place, but the sheriff and prosecutor were still stumped for a motive. Both Gienke and his wife were well liked in the community. Their children had never been in any trouble. The Gienkes were not wealthy, but they did acquire forty acres across the road from their house. "Others wanted that land," Seymour said. "But that would hardly be a motive."

Investigators searched the house and property and found a small amount of insecticide, but it was not arsenic. No spraying devices with which to apply insecticide were located.

Finally, authorities got a break. The blue-and-white coffee pot that Fred had tried to have analyzed fell into the hands of Elyria chemist E.G. Curtis. He found arsenic in some scrapings from the outside of the pot.

This was enough for coroner Crum to order Lilly Gienke's body exhumed from her grave at Myrtle Hill Cemetery in Liverpool Township. The body was taken to D.S. Longacre's funeral home for an autopsy. While Crum saw no immediate evidence of poisoning, he removed the stomach, spleen, liver and one kidney and sent them for analysis. The body was then reinterred.

When the results came back, they showed arsenic was present in Lillian Gienke's organs. Within the same time period, Seymour received an anonymous letter, which the *Medina Gazette* published. It read: "I just want to make a suggestion. See if you can find out if there was any ill feeling between Martha Wise and Lilly Gienke. She claims to have been sick, too, but that may be a lie."

Seymour and Roshon decided it was time to talk to Martha Wise. Police picked her up at the Fairview Hospital in Cleveland, where she was waiting to undergo a slight operation for a skin condition on her arm. She made no fuss and quietly walked out of the hospital to go back to Medina. Seymour, Crum, Roshon and his wife, Ethel, who was the jail matron, began to

question her. She stoutly maintained her innocence for a couple of hours until it started to rain. Ethel got up close to her and whispered, "Drip… drip…drip….You know the rain is the voice of God saying 'you did it…you did it.'"

According to the *Medina Gazette*, Martha finally broke down and confessed. "I put it in the water buckets. I don't know why I did it," she said. "The devil put me up to it."

She admitted to poisoning her mother and her aunt and uncle in a written confession, which was published in the *Medina Gazette*:

On the day before New Years, in the evening after milk I put some arsenic in the water pail. About two weeks after that I put some more arsenic in the water pail. The water pail was always sitting on the cupboard in Gienke's kitchen. I don't know why I did it. I just couldn't help it. The devil was in me. Mrs. Gienke used the water in the pail to make coffee and cook the meals in. The day before my mother, Mrs. Sophie Gienke, took sick I was at her home. She and my brother Fred Hasel, lived in the same house in separate parts. She had her kitchen and Hasels had theirs. I went to my mother's part of the house and put a small quantity of arsenic in the water bucket. Just a pinch of it. The water bucket was sitting on the cupboard in her kitchen.

Along the latter part of January or the first of February, I can't just remember which I put more arsenic in the water bucket at Gienkes'.

This is the last time I used any arsenic. I didn't give Marie any arsenic in the hospital. I took her some oranges that Mrs. Weichter sent to her.

I bought the arsenic at the drug store on the corner in Medina. A short, heavy set fellow sold it to me. He asked me what my name was and where I lived and wanted to know what I wanted the arsenic for. I told him I wanted to kill rats. I bought about two ounces.

When I put the arsenic in the water pail I carried it wrapped up in a little piece of paper. I don't know why I did it I just couldn't help it. Something seemed to make me do it. I lost my mind. My mind wasn't right since last summer. After I did it, it bothered me and worried me. I worried about it all the time. I feel better now. I didn't put any arsenic on my arm. The doctor can tell you that. I only put on what the doctors told me to put on.

I make this statement because I want to and I make it of my own free will. I feel better since I have told you about it.
Martha Wise

Martha's denial of giving Marie arsenic in the hospital came because Fred Jr. claimed his sister was getting better, but she relapsed after having visitors who brought fruit to her and Rudolph. Martha was one of those visitors.

After Martha confessed, Seymour had her placed in the women's section of the jail until the grand jury met. She would be under the watchful eye of Ethel. Her mental state was not clear, and Seymour went back and forth on whether to charge her with first-degree murder or second-degree murder by reason of insanity. He decided to let the grand jury sort it out.

Some of her own relatives suspected Martha from the beginning but hesitated to say anything to the authorities. The anonymous letter may have come from one of them.

While she awaited trial in her jail cell, Martha was examined by two psychoanalysts, who found her to be sane. "[A]lthough possessing a subnormal mind," one said, "she is able to distinguish right from wrong and to resist temptation." The coroner claimed Martha was a "mental and moral imbecile, whose normal side knew little of her subconscious acts."

Martha became dependent on Ethel Roshon, who was her constant companion. She was open with the jail matron and told her that she had set fire to three barns in Valley City. She burned one of the barns after the owner's son shot one of her husband's pigs because it got into the owner's garden. She also admitted to stealing things from neighbors' barns.

On August 8, the Medina County grand jury indicted Martha for first-degree murder. They found she was sane and could stand trial.

A few weeks before the criminal trial was to begin, Merton G. Adams and his wife, Rose, petitioned the probate court to have a guardian appointed for Martha, citing incompetence. Rose Adams was Martha's sister-in-law. She wanted to take the four children. Adams claimed Martha had $1,800 in an account in the Farmer's Bank and that she owned a small house on eighteen acres of land that was worth in total $1,500. Martha's physician, two bankers and relatives from both the Wise and Gienke families testified as to her competence at the hearing. None of the witnesses declared she was insane, but Probate Judge F.O. Phillips heard enough to warrant a guardian.

One day, Martha's four children—Lester, fourteen; Everett, eleven; Gertrude, ten; and Kenneth, seven—plodded their way through the springtime mud to see their mother in jail. Hysterical at the time, she was in no shape to see them. She lay on her bed crying, uttering the constant lament, "I wish somebody would tell me why I did it."

Since the children were unable to see their mother, they talked with prosecutor Seymour. A freckle-faced Lester Wise told him their mother had

warned them never to drink the water at the Gienkes' house. The other three children supported this.

The trial opened on May 4, 1925. It took two days to seat a jury of five men and seven women. The first day of testimony started a little after 9:00 a.m. The streets outside the courthouse on Medina Square were jammed with buggies and cars. Judge N.H. McClure's courtroom was packed with an estimated three hundred people who wanted a glimpse of the poisoner. Every seat was taken. Other people were willing to stand all day. Spectators brought their lunches so they could eat in the courtroom and not miss any of the drama.

Martha was clad in a plain blue gingham dress. Over the top of her dress she wore a brown coat that fell to the tops of her new black patent shoes. Some days she wore an old-fashioned black hat. Other days she wore her black hair piled on top of her head.

Prosecutor Seymour stood before the jury to give his opening statement. It was short and simple. He said the state would prove beyond a reasonable doubt that Martha Wise had deliberately poisoned her aunt Lilly by putting arsenic in the drinking water of the Gienke home. He also said he would not seek the death penalty.

Defense counsel Joseph Pritchard of Cleveland was more emotional. He did not expect to prove she was innocent of first-degree murder but that she was insane and that's why she poisoned her aunt. He gave the jury a brief glimpse of her background. He said she had been epileptic in girlhood. He told them she had been bitten by a mad dog as a child. She married Albert Wise, a much older man, who did not even bother to buy her a wedding ring. It soon became clear to Martha that he only wanted a field hand to help work his farm. While she was pregnant with her first child, Albert forced her to work in the fields. After she gave birth, he made her get up and go back out in the field. That first child died, Pritchard said.

The prosecution put twenty-one witnesses on the stand, including the doctors who had treated the Gienke family, the county coroner, the undertaker who buried and then exhumed Lilly Gienke, the sheriff, the jail matron and the clerk at Wall's drugstore who sold Martha the rat poison. Two psychoanalysts, Drs. H.H. Drysdale and J.S. Tierney, who had examined her in jail, testified that she was sane. But the most potent testimony came from the Gienke family members who survived the poison.

Fred Jr. was the first of his family on the stand. He told the jury how the illness began and then went into detail of how his mother suffered and died three days after getting sick.

By far the most dramatic testimonies came from twenty-six-year-old Marie and seventeen-year-old Rudolph Gienke.

Marie was a pitiful sight as she was brought into court on a gurney. Attended by a nurse, she was wheeled close by the defense table. Martha hid her face in her handkerchief. Marie raised a shriveled arm to take the oath, but she needed help from assistant prosecutor Arthur Van Epp to hold her hand up.

The *Plain Dealer* reported part of her testimony. "And was your illness painful?" Van Epp asked her.

"It nearly tore my heart out," she said, her voice barely above a whisper. She told the court that her limbs were withered and useless.

"And do you know why you are in this condition?"

"Because I was poisoned."

Pritchard's cross-examination was short. He asked her if she and Martha were first cousins. She nodded, turned her head away and closed her eyes.

Marie's gurney was moved close by the defense table again. This time Martha sighed deeply and began to sob.

The next witness was Marie's younger brother, Rudolph. Sheriff Roshon had to carry the frail boy into the courtroom because his legs were paralyzed. They, too, passed in the aisle inches from Martha.

Rudolph testified that he had seen Martha at his house on New Year's Day while his sister and mother were away. He told of the sickness that devastated his family New Year's night and the second wave of it that landed him and Marie in the hospital and finally took his father's life.

Pritchard's strategy to prove Martha insane took shape as he called witness after witness to testify about her mental state. Doctors, relatives, friends, neighbors, teachers and schoolmates took the stand. Many told the court that Martha was peculiar and not very bright. Others' testimonies told the story of Martha's life.

Her teacher said Martha was backward and had left school at fourteen. A schoolmate said she was a slow learner. Two of her neighbors testified that she set fire to their barns and stole tools. Neighbors took note that at each of these fires, she took an active role in fighting the blaze.

A family member said Albert was unkind to her. Another neighbor said he had seen her rolling around on the ground and foaming at the mouth, as her eyes rolled into the back of her head.

Another dramatic moment in the trial came when Emma Kleinknecht, Martha's sister, testified that Martha got along well with her mother. Then Emma began to sob, according to the *Medina Gazette*. "Mother said that

Martha was not capable of taking care of her own affairs and she was always worrying for fear that she would be neglected." Emma's words came haltingly. "The last thing mother said was 'See that Martha's taken care of after I'm gone.'"

Emma related how her sister had been bitten by a dog when she was sixteen. She said her sister was sick for about a week but then was seized with a relapse three months later. Emma told the court that Martha frothed at the mouth and her eyes got glassy and rolled to the back of her head.

Martha often had visions, Emma said. Her visions started out being of angels at the gates of heaven with white doves surrounding her. But then her visions became darker, and she told Emma how the devil came to her at night and tempted her to do awful things.

Emma said Martha's marriage and home life were miserable and that she toiled in the fields day and night. Her mother-in-law was cross with her and always found fault.

Martha's brother Paul Hasel came to the stand next. He said his sister's actions in the previous summer were strange. Instead of sleeping at night, she roamed the fields and claimed that the devil visited her on these walks. He also testified that Martha had a temper.

A few days into the trial, the defense was dealt a setback and the family suffered yet another loss when Martha's sister-in-law Edith Hasel committed suicide in the outhouse by making deep gashes in her own throat with a case knife. She had always been frail mentally but had been in great pain since losing so many family members. She brooded over the trial and was paranoid that people would think that she had poisoned the family.

Pritchard knew that Edith had hallucinations, so he had planned to put her and her husband on the stand. As he questioned them, he would plant the idea in the jurors' minds that poor Edith was capable of poisoning the family.

Edith's funeral was held at the house she, her husband and their son had shared with Sophie Hasel. As the neighbors gathered, they began to talk. It came out that Martha had been seeing a man and wanted to marry him. They knew her family was against her remarrying on religious grounds. Sophie disapproved of her daughter having male friends and forbade her to remarry. After Sophie died, Fred Gienke began to admonish her. One day, he picked her up and shook her. He told her to mend her ways. The gossips were sure that was why Martha had poisoned them.

A week into the trial, the *Plain Dealer* reported that young Lester Wise told Rose Adams he had overheard a conversation between his mother and a

man. "My mother and a man were talking when I came into the room one day last November and I heard them mention poison." He heard them say "the best way to do it." When his mother realized he was in the room, she ordered him to leave the house. Later, she warned him never to repeat what he had heard. Rose made Lester swear he was telling the truth on the Bible.

"Mrs. Wise was the one who administered the poison and she has confessed to it," Seymour said when Rose related what Lester had said. "If it can be proved that someone knew about it, we will hold him."

On May 13, the jury took one hour to come to a decision. Martha Wise was guilty of first-degree murder. Judge McClure sentenced her to life at the Ohio State Reformatory for Women at Marysville. Hearing her fate, Martha slumped in utter hopelessness.

Later in her jail cell, she wondered what would happen to her children. Her defense had taken almost every penny she had. "They'll have to get a guardian or get adopted. There won't be much for them."

Seymour and Van Epp questioned Martha about the man young Lester overheard talking with his mother. Martha told the prosecutor and her

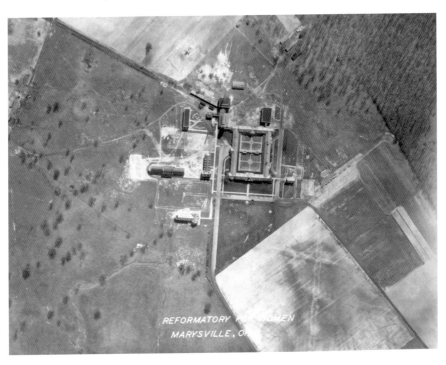

The Ohio Reformatory for Women at Marysville. *Courtesy of Ohio History Connection.*

attorney that Walter Johns, a machinists' foreman from Cleveland, had put her up to poisoning her mother. "I never intended to tell," she told a reporter for the *Canton Repository*, "but now that everybody is talking about it, I can't hold my tongue any longer. He never came to see me in the jail and at the trial he never looked at me, although he was there every day."

"We have the giver of the poison. If there is someone else connected that is a separate matter," Seymour said. He swore out a warrant for Johns, charging complicity in the murder of Martha's mother.

Pritchard also wanted to know about this man, but for a different reason. He still hoped to show that Martha was not responsible for her actions and that Johns had pressured her into poisoning her family.

Johns was a fifty-nine-year-old father of five who had worked at the same job for thirty-two years. He was arrested on May 15 and taken to Medina for questioning. Seymour said he was thinking of exhuming Sophie Hasel's body, but first he wanted to hear what this man had to say. He started by asking Johns about quarrels Martha had had with her relatives over the two getting married.

Johns said he had heard the story but it was lie. Seymour asked if he had ever had a fight with Paul Hasel, Martha's brother. Johns denied it, saying he liked Paul. When Paul was questioned about it, he insisted they had quarreled at Martha's home. One of the Gienke sons told the prosecutor he often carried notes back and forth between Martha and Johns.

Seymour grilled the man for six hours but got nowhere. Finally, he decided to have Martha and Johns meet face to face. The conversation was reported in part in the *Canton Repository* and the *Plain Dealer*.

"He made me do it. He put me up to it," Martha shrieked. "He kept at me to do it. He told me I should get the arsenic and get rid of my mother, and then I'd be free."

"She lies," he claimed. "I don't know anything about her and what she did."

Martha told the prosecutor, "He put me up to it. I never would have thought of such a thing." Perhaps she wanted to get even with Johns for not coming to see her in jail. He claimed he did not visit her in jail to "make it easier for her."

After Johns and the attorneys left, Martha sank back onto her bed in her cell. The blue gingham dress she had worn all through the trial was neatly folded on a chair. The *Plain Dealer* reported that Johns had given her ten dollars as a Christmas gift, and she had bought the dress with the money.

Seymour put Johns in a cell and told him to write everything he could think of that took place during the time Martha had poisoned her family.

Above: Inmates working in the field at Marysville, one of the jobs Martha probably had. *Courtesy of Ohio History Connection.*

Left: Martha Wise as an old lady. *Courtesy of Ohio History Connection.*

It took him quite a while, and the document he produced was lengthy, but nothing in it was useful to the prosecutor.

Seymour released Johns. "We have no evidence to corroborate the statements of Mrs. Wise."

Martha was transferred from the Medina County jail to Marysville on May 23. Oddly enough, the confessed poisoner was assigned to work in the kitchen at first. Through the years, she had a variety of jobs, from laundry duties to raising chickens to sewing rags to making rugs.

Martha was seventy-nine years old in 1962 when Ohio governor Michael V. DiSalle commuted her sentence from first-degree to second-degree murder. After thirty-seven years, she was free, but she had nowhere to go. No one in her family would take her in, so the state made arrangements for her to go to a Blanchester nursing home in Union County.

When Martha arrived at the home with Helen Nicholson, her probation officer, proprietor Muriel Worthing refused to take her. She had been unaware of Martha's history when she first consented to take her in. "I'm a food caterer. This is a small town. What do you think would happen to my business? I'd even lose my job as a cook I'm holding now."

As a result, Martha spent the night at Nicholson's house and was driven back to Marysville the next morning, where she lived another nine years. She died on June 28, 1971, and was buried in Marysville.

THE WOMAN WHO COULD NOT CRY

Dovie Blanche Dean (1952)

On April 12, 1952, Hawkins Dean signed a new will, leaving everything to fifty-five-year-old Dovie Blanche Smarr Myers, his intended bride. His estate was valued at more than $27,000. The wedding took place the next day. Little did he know his signature on that will would cost him his life.

Hawkins was a sixty-eight-year-old farmer who owned 115 acres on Belfast-Owensville Road, just north of Owensville in Clermont County. Dovie was his third wife.

Dovie, mother of five children and grandmother of seven, lived on Titus Road, just a stone's throw south of the Dean farm. She came to Ohio from her native Charleston, West Virginia, in 1950 to keep house for one of her daughters. She had worked as a domestic most of her life.

Hawkins was her second husband. Her first marriage was to Carl G. Myers Sr., who had worked in the oil fields. He was two years younger than Dovie. She left him in 1938, when he was convicted of assault for raping their oldest daughter, Kathleen. He was sentenced to seven years in the West Virginia State Penitentiary. Two years later, Kathleen died in childbirth from complications caused by that assault.

"I met Hawkins at my daughter's house in January, 1951," she told Howard Huntzinger of the *Columbus Dispatch*. "His wife died later that same year," she added. According to Huntzinger's article "Convicted Killer Dovie Dean Says God to Set It Straight," published on December 16, 1952, she and Hawkins saw each other several times at social gatherings.

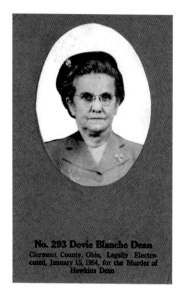

No. 293 Dovie Blanche Dean
Clermont County, Ohio, Legally Electro-
cuted, January 15, 1954, for the Murder of
Hawkins Dean

Dovie Dean was electrocuted for
the murder of Hawkins Dean.
Courtesy of Ohio History Connection.

In February 1952, tragedy struck Dovie again. Her son John Andrew Myers was scalded to death when a boiler he was repairing blew up. She came to Charleston for his funeral. While she was there, Hawkins wrote her that he wanted her to either marry him or become his housekeeper. "I told him I couldn't live there [at the Hawkins Dean farm] unmarried." And furthermore, she could not marry him because she was not divorced from her first husband. "He offered to pay for my divorce. So we talked it over and I applied for a divorce."

The divorce came through on April 11. The next day, Hawkins drew up a new will, making her his sole beneficiary and declaring his intention of marrying her. She later claimed that she had to help him because he could not read or write very well. His eyesight was failing, and he refused to wear glasses, because it made him look old.

They were married by the Dodsonville Methodist Church's minister at the minister's home. After the wedding, Dovie and her son Carl G. Myers Jr. moved to the farm, where she began to keep house. Her son helped with the farm chores.

According to Dovie, and written in Huntzinger's article, Hawkins began to feel poorly in July due to "gall bladder" problems. Or it might have been "food poisoning," she said. At any rate, he was hospitalized at Christ Hospital in Cincinnati from August 8 to 15. Not long after he came home, he began vomiting again. He grew weaker and weaker and was dehydrated. Most of all, he complained that his stomach felt hot. He was clearly in agony.

Hawkins's only child, Mrs. Mae Perry, described his condition as "pitiful," according to Richard Crawford in "Dean Murder Trial in 1952 Captivated Clermont, and Nation" published in the *Clermont Sun* on March 9, 2007. "His hands and feet were drawn, his flesh dried. He kept asking for water and vomiting." But Dovie reassured her that it was nothing more than a viral infection and that he would be all right.

By the morning of August 21, Hawkins Dean was dead, just four months and nine days after signing his last will and testament, leaving his entire estate to Dovie Dean. Although some newspapers give his death date as

August 22, the death certificate signed by Dr. Joseph Batsche, his physician, gives the date as August 21 at 4:00 a.m. with a question mark next to the time of death.

Dovie told Huntzinger that just before Hawkins's death, she was cleaning his room. He told her to get some sleep. She sat down and closed her eyes. He apparently noticed that she still had her glasses on, presumably because she was keeping watch over him. She took her glasses off and drifted off to sleep for only "about a half hour," she claimed. When she awoke, she jumped up and touched his arm, but he was cold—after only a half hour.

Her children, Carl Jr. and Dorothy King, were upstairs. She yelled for them to come down. Carl looked at Hawkins and said, "He's dead, Mom."

Moore Funeral Home held visitation hours for Hawkins. He was buried in the Stonelick Township Cemetery next to his second wife, Demma. Strangely, Dovie shed no tears.

Mae Perry insisted on an autopsy, telling authorities that even her father was suspicious toward the end. He asked for an autopsy in the event of his death. A week later, Dr. Frank Cleveland, the Hamilton County coroner, performed it. More than six grams of arsenic were found in Hawkins Dean's organs, twice the amount needed to kill a man. When his body was removed from the house, someone had thought to pick up the glass on the night table beside his bed. Arsenic crystals were found in the milk in the glass.

On September 4, police arrested Dovie, Carl and her son-in-law, Clyde Bryant, and housed them in the Clermont County jail. The three were subjected to lie detector tests. Nothing has been written about the results from Dovie's, but Sheriff Clyde Dericks was convinced of Carl's innocence after the tests. Her son-in-law was also released at some point.

Dovie sat behind bars and claimed her innocence for three weeks. Finally, after a long period of questioning, she began to break down. At first, she accused her son of the killing. According to the *Plain Dealer*, Dericks told her that a mother who would accuse her son of such a killing "could easily have done it herself."

At last, she said, "I did it."

Dovie dictated her confession with prosecutor Ray Bradford and his assistant M. Dale Osborne in the room. She claimed to have killed her husband after many violent arguments prompted by his inability "to perform marital relations after their marriage." She claimed he "threatened to kill her and then take his own life." She said she gave Hawkins a few drops of Zip Rat Poison, which is tasteless, in milk four different times, including the night before he died. "He wanted a housekeeper and I wanted a home," she

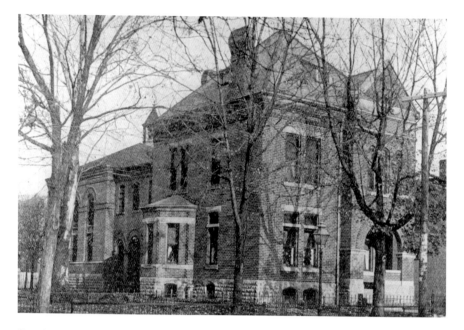

Batavia sheriff's residence and jail. *Courtesy of the Clermont County Public Library, Sharp Collection.*

said. The sheriff's department searched the Dean farm and found a bottle of Zip Rat Poison hidden in the coal shed.

Dovie's confession was notarized by Osborne and witnessed by Deputy Charles E. McNutt and, oddly enough, her son. There were references in newspapers to her being given medical attention after she signed her confession, but no reason was reported. However, it was mentioned several times by authorities and in the newspapers that she never cried.

The grand jury took a half hour to indict her for first-degree murder.

In October, trial judge Harry Britton ordered Dovie into the Lima State Hospital for a thirty-day evaluation to see whether she was mentally fit to stand trial. On the assurance that she was capable, the trial opened in December with Britton on the bench and Bradford and Osborne at the prosecution table. When asked who she wanted to defend her, she chose her dead husband's administrator, Hugh Nichols. Ben West and John Watson were appointed to assist Nichols.

"Hawkins Dean signed his death warrant when he signed his will," Bradford told the jury of seven men and five women during his opening statement, an article in the *Cincinnati Enquirer* stated. He called the murder "the most gruesome crime in Clermont history."

In his opening statement, Nichols told the jury, "We expect to prove that Dovie Blanche Dean did not and could not have killed him." He went on to say, "We are not going to try to tell who killed Hawkins Dean. Numerous persons could have." He concluded by saying, "She was perfectly happy. It wasn't a love match, but it was most satisfactory."

Bradford introduced the will made out the day before the wedding. It mentioned the impending marriage and left her husband's entire estate to Dovie for her use during her lifetime. At her death, the estate would revert to Hawkins's daughter.

The first person to take the stand was Hawkins's daughter, Mae Perry. She told the court of her father's illness and his suffering. "Dad was deathly sick and moaning," she said.

On cross-examination, Nichols elicited Mrs. Perry to say that Dovie was "a good housekeeper, took good care of him and from all appearances was fond of him."

The prosecution introduced Dovie's confession by having Osborne read it on the stand. The defense strongly objected to this and tried to prove the confession had been obtained by duress, but Judge Britton allowed the jury to hear it.

Batavia Courthouse. *Courtesy of the Clermont County Public Library, Sharp Collection.*

Dorothy King, Dovie's daughter, broke down on the stand when Bradford asked about a "big party" at the farm a few days after Hawkins died. He also asked if it was true that her mother "got a gun and whooped it up."

It took a while for Dorothy to regain her composure, but she said there may have been a "beer or two," but there certainly was no big party. Her husband, Leslie King, and her brother, Carl, were there. She admitted that her mother had a few beers and fired a gun, but it was at a prowler. The prosecution had gathered the information on the party from neighbors who heard the racket.

Bradford reminded Dorothy that she had told the prosecutors "most of mother's money went for whisky and beer" when they lived in Charleston, West Virginia. Dorothy denied ever saying that.

Near the end of the trial, the accused took the stand in her own defense and denied that she "knowingly" gave her husband rat poison. She also claimed she had never read her confession. She told the jury she signed it after being told her children had turned against her, so "there was nothing to live for."

She testified that Hawkins had taken a white powder the day before he died. She claimed he asked her to get the powder out of his overalls pocket and that he took it from a spoon and then drank a glass of water. He took the powder because it calmed his nerves, she said.

"I did everything I could for him." She described her marriage to Hawkins as the happiest time of her life. "I was satisfied with the marriage."

According to the *Columbus Dispatch* of December 13, 1952, Bradford's closing argument included: "I wonder if the happiest moments were not on August 22 when she stood and watched the last breath of Hawkins Dean." Then he remarked how she had smiled during the trial, "as though this whole thing were a joke."

Nichols told the jury that Dovie had signed the confession to protect her son and son-in-law. "She never has accused them and never will," he said. "What kind of son is that?" he asked in referring to Carl Jr.'s signature on the confession.

The jury took a mere forty-five minutes to convict her of first-degree murder with no recommendation of mercy. It was a mandatory death sentence.

Upon hearing her fate, she tensed slightly then leaned back in her chair. She lowered her head and brought a handkerchief to her face, but no tears rolled from her eyes.

When Judge Britton asked if she had anything to say, her only comment was, "All I have to say is that I'm not guilty."

Courtroom in the Batavia Courthouse. *Courtesy of the Clermont County Public Library, Sharp Collection.*

Although she was on trial for her life, tears never formed in her eyes. One account said she could not cry because she had no tear ducts. A psychiatrist probably came closer to the truth when he said she was psychologically incapable of showing emotion. She and her defense team wondered if this hurt her in front of the jury. "When I got on the witness stand, they made light of me because I couldn't cry," she told Mary McGarey of the *Columbus Dispatch* for a January 10, 1954 article, "Time Runs Out for Dovie, Due to Die Next Week. "Nobody seemed to remember there's been a death and I had grief inside, like knives."

Nichols indicated that he would appeal up through the state courts and to Governor Frank J. Lausche if need be. In September 1953, Nichols went before the Ohio Supreme Court in a bid to save Dovie. He said the trial court's failure to include lesser charges than first-degree murder was an error. The court refused to review the conviction.

"I expected to have my appeal turned down and, if it's God's will, that is what will be done," she told the *Plain Dealer*. Housed in the Marysville Reformatory, she awaited word on the appeal. She stayed busy playing

with her parakeet, Charlie, crocheting collars for her granddaughters and pillowcases for her grandsons, doing crossword puzzles and keeping her room clean. She became very religious and read her Bible often. During the last week of her life, she was baptized and took First Communion.

Finally, an appeal to spare Dovie's life landed on Lausche's desk. The governor ordered her execution postponed until he had a chance to study the trial transcripts and confer with the state pardon and parole commission. He spoke with Judge Britton, the appellate court judges and the Ohio Supreme Court judges and came to the conclusion that he could not intervene. "Regrettably, based upon the study which I made and in spite of my desire to be of help to her, I cannot justifiably intervene." He waited until January 15, 1954, the day of her execution, to give his decision.

It was a cold, rainy day. Dovie was not told of Lausche's decision. Her radio had been taken out of her cell, so she could not hear news broadcasts.

Ohio State Penitentiary death house. *Courtesy of Ohio History Connection.*

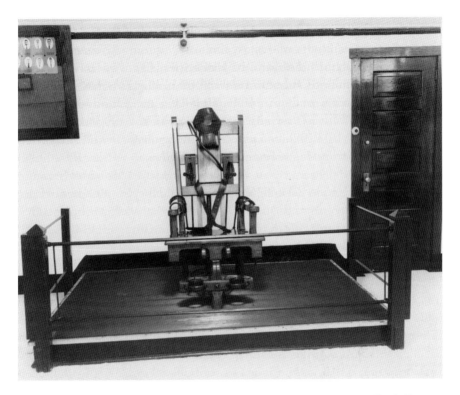

The electric chair. At left is a photo of past inmates who met the same fate as Dovie Dean. *Courtesy of Ohio History Connection.*

She seemed unconcerned and even had her hair done in the afternoon. Her last meal consisted of chicken and dressing, mashed potatoes and gravy, salad, asparagus, angel food cake and custard pie.

Before she was taken to the penitentiary in Columbus, she gave her parakeet to Velma West. As the time drew near, the warden's car came to take her to her final destination. The timing was set so that she would arrive at the penitentiary minutes before she would die. She wore a simple flowered dress, white ankle socks and brown, flat-heeled shoes. The crown of her head was shaved so the electrodes could make contact.

Dovie was escorted into the death chamber by the Catholic prison chaplain, L.V. Lucier, and a Protestant minister, C.W. Wilsher. Head bowed, she walked past the photos of others who had met their deaths by legal execution. She sat down in the electric chair, hands gripping the armrests. She had asked to hear the hymn "What a Friend We Have in Jesus," but no one was able to sing it, so Reverend Wilsher recited it.

Throughout, she remained emotionless and made no eye contact with anyone.

At 8:00 p.m., Warden Ralph W. Alvis ordered the switched pulled.

Two days later, Dovie Blanche Dean's body was lowered into the frozen ground next to her son's grave at the Cunningham Memorial Park in St. Albans, West Virginia. Three ministers conducted a simple service. Three of her four children, all eight of her grandchildren, and an estimated eight hundred curiosity seekers braved the frigid weather to attend her funeral. Perhaps the saddest mourner of all was her father, eighty-three-year-old John Smarr. The Dunbar Mountain Mission Quartet sang "What a Friend We Have in Jesus."

THE *DEMIMONDE* OF CLEVELAND

Clara Palmer (1881–97)

*C*lara Palmer operated one of the most successful and high-class houses of ill-repute in Cleveland during the 1880s and '90s. She came to Northeast Ohio from Bradford, Pennsylvania. While some of the citizens of that city may have been glad to see her move on, members of the city council probably missed her.

An article in the *Oil City Derrick* in April 1881 stated, "Whenever a little money is wauled [*sic*] all that is necessary is to call on the girls." On Thursday, April 28, 1881, police raided nine cathouses throughout the city of Bradford. Fifty women were rounded up to answer to the usual charges. It was a lucrative haul. The mayor fined the "landladies" $25 each. Clara was one of the aforementioned to hand over the money. The inmates (a term used for the women in the brothel) were fined $5 each. By the time the mayor, who sat in judgment of the women, was finished collecting the fines, the city coffers were enriched by $430. The women paid their money and went back to their respective houses to await clients.

Sometime after that, Clara came to Cleveland, a move that left behind several unpaid bills, including $500 for a rented piano that, along with her other possessions, burned up in a fire. She also owed local merchants money and failed to pay them before she left Pennsylvania.

Clara settled into a Cleveland mansion at 22 Hamilton Street and opened her bordello, fitting right into the neighborhood. The *Cleveland Leader* called her brothel the "most guilt-edged house of immorality in Cleveland." The newspapers often called her a *demimonde*, a French term for women of

doubtful morality. There were a number of other "immoral resorts" in the area known as the Tenderloin district. Hattie Ward ran a bawdy house at 138 St. Clair. James Robinson's gambling house was only blocks away. Lizzie Hayes opened the doors of her house on Champlain Street to gentlemen. Seneca Street was the site of Sadie Russell's brothel, conveniently located close to a saloon. The house of Lottie Adams (a.k.a. Elliott) was at 63 Michigan Street. It was a popular destination for men. Other madams in the city included Nellie Leon, Mabel Gray, Anna Tripp, Anna Palmer and Clara Brown.

High rollers at Robinson's roulette wheel would gamble for hours and then visit Clara Palmer's house, often bringing along friends and cases of champagne. One of those gentlemen, John C. Campbell, visited the gambling establishment and Clara's house three or four times a week, spending $400 a week on wine and women during a six-month period. It was later found that he was an embezzler.

Cleveland police pulled one of the first of many raids on 22 Hamilton Street in the early hours of Monday, May 18, 1885, and arrested Clara and three of her inmates. The women were doing business with four men who gave fictitious names. Police carted all eight prisoners by hacks (horse-drawn cabs) into the station and began searching them. One of the men was carrying a stolen watch connected to a brass chain with a lead pencil. It was assumed that his stylish clothing was "borrowed from a tailoring establishment to be exhibited as an advertisement."

A drummer from Boston, who was one of the men collared, seemed to take his arrest in good spirits. "Really this is an unexpected honor," he said as the cell door closed behind him. "I am a stranger here, and the most I could have expected from the city was an escort, but I see you also very kindly furnish me with quarters." The other three men were also furnished lodging for the night at the jail.

Clara forked over bond for herself and her three employees, calling them "family," and they went home. It was all matter-of-fact. Police raids were to be expected.

Lottie Adams's house on Michigan Street had been raided around the same time. The *Cleveland Leader* said the house was "in full blast" when police arrived and put a damper on things. The inmates there had been entertaining nine men, mostly from out of town. All were taken to the central police station.

At court on the following Tuesday, two men from Lottie's house pleaded not guilty, claiming to be in the barroom at the time of the raid. The court

believed them, and they were let go. Seven of the men were each fined the usual ten dollars and costs. The four men captured in Clara's house pleaded guilty and were fined the same ten dollars and costs. Lottie Adams was fined fifty dollars and costs. Her employees each paid the regular fee of ten dollars and costs.

When it came time to hear Clara's case, the judge asked the arresting officer if anyone had made any complaints against the house. "This court doesn't want to be left out in the cold in these cases," said the judge. "And if any complaints have been made I want to know it, so I can give them a little extra dose." The arresting officer assured him there had been no complaints.

The judge then asked if the "Palmer domicile" was not considered a "tony" place. Upon being told that indeed it was, the judge upped her fine to sixty dollars and costs. Her employees were fined ten dollars and costs.

Due to the "sensitive natures and inherent modesty" of the men, the proceedings had been conducted in a private courtroom.

The police court fund and patrol system were running low on money in September 1886. To alleviate the problem, authorities decided to raid the main brothels. They figured they could raise around $1,000 from the fines levied against the women and their customers. Apparently, everyone in the central part of the city except the prostitutes themselves knew the raid was coming, because at least two hundred people gathered in front of the station to watch the "fun."

On Saturday night, September 25, 1886, Cleveland police conducted one of the most extensive raids against the city's brothels. Captain Henry Hoehn, who would later become Chief Hoehn, headed up four squads of twenty-five policemen. The raid commenced about 10:00 p.m. Mable Gray's third-story bordello on the Square was first. Four women and three men were arrested. One of the men was big and heavyset. He made a dash for the open window and tried to leap to the ground. If a patrolman had not caught him, the three-story fall might have killed him. All seven people in the house were arrested.

Lizzie Hayes's house on Champlain Street was next. Police entered a side door and made their way to the parlor, where they found six women and two men. All were given a ride to the police station. Five patrolmen called on Nellie Leon's house on Ontario Street, where they pinched four women and their three customers. Five women in Hattie Ward's house on St. Clair were nabbed. Nine policemen hit Clara's house and escorted eight women and two men into the black Maria (a term used for the early patrol wagon).

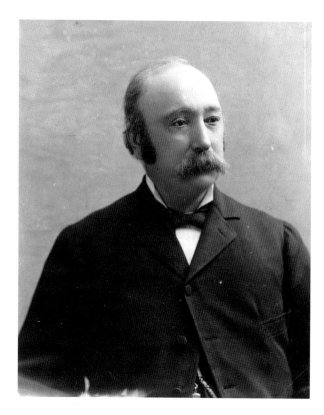

Cleveland police captain Henry Hoehn organized a raid on downtown brothels. He later became police chief. *Courtesy of the Cleveland Police Museum and Historical Society.*

The raid took less than a half hour and netted thirty-eight arrests. The women, dressed in silks and satins, were held for a short time in the women's prison. Their customers jammed the hallways in the police station. The men were all well dressed, wearing high hats and fashionable suits of expensive fabrics. They were professional men, young and old, and many gave fictitious names. The *Plain Dealer* reported that Cleveland's elite was well represented in the police hallways that night. One of the gentlemen was a member of the school board. Others included a prominent physician, a leading merchant and "a number of goody-goody young men who attended church regularly and were 'as pure as the driven snow.'" By midnight, all the prisoners—men and women—had given bail and were released. The women paid a total of $633. The amount coming from the men was not printed, but the fines went a long way to bailing out the police court fund.

The house at 22 Hamilton Street was raided at least once a year. During one appearance before the judge, Clara was fined $100 for keeping a house of prostitution, and her employees were fined $20 each instead of the customary $10. Clara must have figured the fines were part of the cost of

doing business, because she never shut her doors. When she needed legal representation, she hired Martin A. Foran and E.J. Blandin; both later became judges. If she saw the inside of a jail cell, it was not for long.

The Woman's Christian Temperance Union (WCTU) held its first national convention in Cleveland in 1874. By late 1893, the local chapter put the demimondes and their bordellos in its crosshairs. County prosecutors heard the demand and took cases against Clara, Alice Palmer, Mattie McGowan and Clara Brown to the grand jury. The women were indicted and arrested in January 1894.

Deputies knocked on Clara Palmer's door around 10:30 in the morning. She was still asleep but showed little surprise when awakened. She did say "the affair was rather sudden." She dressed and accompanied the officers to the central station. The others had also been awakened, and officers waited for them to dress before escorting them to the jail. The four women sat on chairs in the corridor of the police station as they gave their names, ages and places of birth. The criminal docket was crowded, so their cases were transferred to the probate court, as misdemeanors were often heard and had simultaneous jurisdiction in probate court. Weeks later, the law changed as far as Cuyahoga County was concerned.

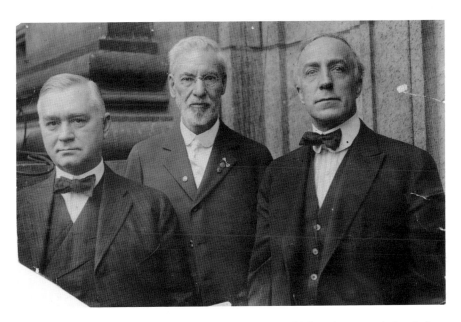

Attorney Martin A. Foran (*center*) defended Clara Palmer. He later became a judge. Judge P.L.A. Lieghley is on the left and Charles Higley is on the right. *Courtesy of the Cleveland Public Library.*

Clara's trial came first. Martin A. Foran and E.J. Blandin defended her. Before the jury was seated, her two attorneys argued that there was a question of jurisdiction because the case had been brought in common pleas court and transferred to probate court. Foran said, "The action reminds me of the conduct of the French general who marched his troops up the hill and marched them down again, knowing nothing better to do."

The tall Blandin rose to his feet and asked in a quiet, sure voice that the charges against his client be quashed (voided) on the grounds that the court had no jurisdiction over her. Another Cleveland attorney, Jay P. Dawley, also filed a motion with the court to have Clara's case quashed.

Judge White held all the motions under consideration and took some time to deliberate the question. When he came back to the bench, he had his decision. The way he looked at it, the question was not whether the probate court had jurisdiction over the criminal act, but whether it had jurisdiction over the defendant. "The repeal of the act of February 6 conferring jurisdiction of misdemeanors upon the probate court withdrew all power of

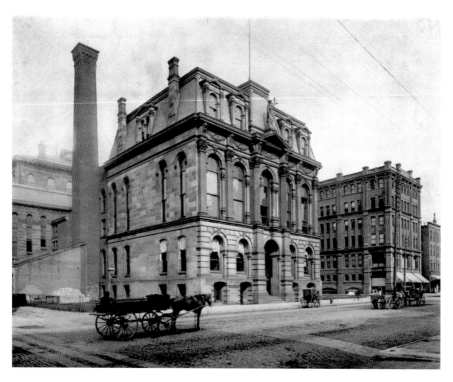

Cuyahoga County Courthouse, circa 1890. *Courtesy of the Cleveland Public Library.*

this court to exercise jurisdiction over the said defendant." He found it "dangerous" in attempting to "exercise doubtful judicial power and the risk of incurring expensive, lengthy judicial proceedings in error and appeals is manifest in a case like this at bar." He dismissed all four cases. Dawley called it "the soundest opinion from the bench for some time." Clara and the other women were free to continue business as usual.

While Cleveland policemen often raided Clara's and the other madams' houses, they occasionally visited the houses to enjoy themselves. On one of those occasions, it went terribly wrong for police director "Colonel" John W. Gibbons and Detective John "Jack" Reeves.

E.J. Blandin joined Martin A. Foran in defending Clara Palmer. *Courtesy of the Cleveland Public Library.*

Gibbons and Reeves visited 22 Hamilton Street sometime between 9:00 and 10:00 p.m. on February 8, 1893, where they dallied in the company of Clara for about four hours. While there, they drank four bottles of wine. Somewhat inebriated, they left around 1:00 a.m. and headed over to Grace Graham's house at 64 Ontario. Gibbons was determined to see Grace but in his drunken state had a problem climbing the stairs to her chamber. Reeves tried to steady the police director.

Kittie Clifton, an inmate of the house, stood in their way, explaining that Grace had a bad foot and was not taking visitors. Gibbons told Reeves to "remove this woman." Reeves grabbed hold of Kittie and dragged her part of the way down the stairs and threw her off the last steps.

About 3:00 a.m., Gibbons and Reeves left Grace's Ontario house and made their way to the Oyster Ocean on Bank Street to eat and have another bottle of wine. By then, Gibbons was completely intoxicated. Reeves had also had too much, and the two took a hack and went home.

Reeves should have made a written report on what happened that night, but he failed to do so. When the city officials heard about Gibbons and Reeves's evening out, Gibbons was forced to retire. Reeves was charged with violating the rules and regulations of the police department. Officials were hoping Reeves would resign quietly. Instead, he chose to fight and hired Martin A. Foran and Jay P. Dawley, the same two attorneys who were accustomed to defending Clara and the other madams.

Left: Detective Jack Reeves almost lost his job because of a night at Clara Palmer's as well as other establishments. *Courtesy of the Cleveland Police Museum and Historical Society.*

Right: Jay P. Dawley and Martin A. Foran defended Jack Reeves before the police tribunal. *Courtesy of the Cleveland Public Library.*

In June, Reeves went before the police tribunal, which was composed of the mayor, police director and city council president. They found him guilty of "conduct unbecoming an officer and gentlemen" and neglect of duty. He was found not guilty of failing to write up a report of his duties on that fateful evening. Reeves was suspended for a few days and fined twenty-five dollars.

In March 1894, the *Plain Dealer* reported that a citizens' league employed men to watch the "houses of ill fame." They kept an eye on Clara's and Alice Brown's houses one Saturday night and Sunday morning and reported thirty-one men entered Alice's house and twenty-one visited Clara's. From 1:00 a.m. on, carriages drove up almost constantly to Clara's door. By 6:15 Sunday morning, three carriages were still standing outside, waiting for their occupants who were in the house.

Ordinarily, rounds of "treats and drinks" were one dollar each, but on this particular evening they were double. Two black waiters served the refreshments and a black "professor" entertained at the piano. The citizens' league spies said Clara was highly visible among the other seven women and the housekeeper.

Brothels, saloons and gambling parlors drew criminals to the inner city. The prostitutes sometimes became victims of violence and theft. At times, the women were thieves, stealing from one another or their clients. They often quarreled among themselves and got into physical altercations. Over the years, Clara had money, clothes and jewelry stolen from her. Drunken customers became clumsy and broke a stained-glass window and an expensive silver vase. On one occasion, a rogue passed a bogus $100 bill. In this instance, Clara helped the police track down the culprit.

Clara and seven other demimondes were arrested for operating houses of prostitution in September 1896. As usual, they paid their fifty-dollar fine and costs and went home. It may have been her last brush with the law, because she was diagnosed with cancer around that time.

Clara must have known she was dying, because on January 9 she made out her will. Newspapers reported her estate was worth anywhere from $30,000 to $120,000. She left her properties on Lake, St. Clair and Hamilton, along with her considerable personal property, including diamonds and other jewelry, to Sigmund S. Stein Jr. Stein may have been related to her or just a very good friend. Records show some real estate transactions between the two. Whatever their relationship, he is buried close to her.

Clara Palmer died on January 18, 1897, at the St. Clair Street Hospital during an operation for cancer. Newspaper obituaries gave her age as anywhere from thirty-seven to fifty-five. Her death certificate listed her birth year at about 1860, which would have made her thirty-seven. Her place of birth was listed as Germany.

Her funeral was a small, quiet affair two days after her death. Reverend Edward W. Worthington officiated at a brief service at the Rocky River home of Sigmund Stein Sr. Reverend Worthington spoke of uncertainty in life and influences that work on lives.

Six pallbearers carried her casket to a waiting hearse that drove through a blinding snowstorm to her final resting place at Woodland Cemetery. The hearse and mourners left her there with the gravediggers to cover her casket with earth.

A reporter for the *Cleveland Leader* wrote, "The snow continued to fall in heavy blasts, and in a few minutes the last trace of a woman forgiven and forgotten had disappeared."

THE BLOND BORGIA

Anna Marie Hahn (1937)

*A*nna fingered the gold cross that hung from a chain around her neck, her hazel eyes following the Hamilton County prosecutor as he moved around the courtroom. The thirty-one-year-old blond listened intently as Dudley Miller Outcalt hammered out the murderous charges against her. "Anna Marie Hahn did unlawfully, purposely and by means of poison kill Jacob Wagner."

Outcalt's opening statement at Anna's October 1937 trial for the murder of the seventy-eight-year-old German gardener she called "Uncle Jake" held a packed courtroom spellbound. Within the next few weeks, the *Cincinnati Enquirer*, as well as newspapers around the state and nation, followed the trial that revealed at least five older people who had died by Anna's hand and one who lived to tell his story in court. Her method and motive for the murders earned her the nickname the "Blond Borgia."

To hammer home his point, Outcalt referred to the death of Johan Georg Obendoerfer, sixty-seven, who died under mysterious circumstances while traveling with Anna to Colorado. He spoke of sixty-seven-year-old George Gsellman, whom she promised to marry and whose suspicious death she was under indictment for.

At last, defense attorney Joseph Hoodin sprang to his feet and objected to the prosecutor naming other old men Anna had befriended. He asked Judge Charles S. Bell to dismiss the jury, as Anna was on trial only for Wagner's death. Surely Outcalt's comments about any others would prejudice the case. Bell decided against Hoodin but made it clear to the jury that the prosecutor's comments were not to be taken as evidence.

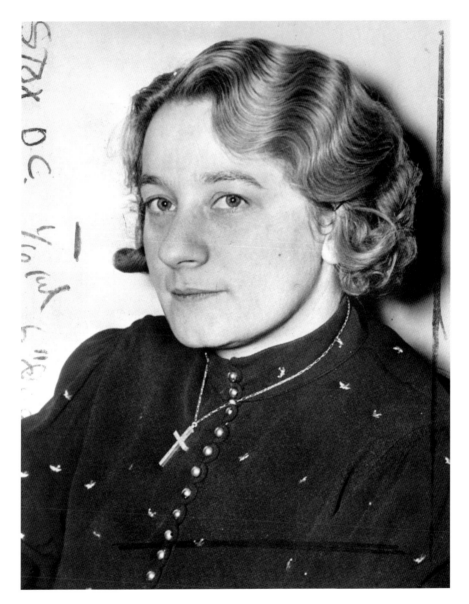

Anna Marie Hahn wore a cross throughout her trial. *Courtesy of Cleveland State University Library.*

In *The Good-bye Door*, author Diana Britt Franklin wrote that Hoodin gave a less impressive opening statement than Outcalt. He told the eleven-woman, one-man jury that Anna's defense was simple. "She did not administer poison to Jacob Wagner." Hoodin hit his stride when he launched into an

attack on Cincinnati police captain Patrick Hayes, who questioned Anna and investigated the case.

Hoodin said that while searching the Hahns' house, Hayes had confiscated a toy gun that belonged to Anna's twelve-year-old son Oscar. He belittled the detective by saying, "He claimed it was the most dangerous weapon he had ever come in contact with. He also poured buckets full of water on Oscar's toy chemistry set."

Anna Marie Filser came alone to the United States from Bavaria, Germany, in 1929. She had given birth to a son out of wedlock, an embarrassment to her devout Catholic family in their small town of Füssen. At her mother's suggestion, she left Germany and her three-year-old son behind and came to America to start a new life free of shame and gossip.

At first, Anna lived with a distant uncle and his wife while working housekeeping jobs. She owed them money for her shipboard passage but never paid it back. It soon became evident to her relatives that she spent more than she made. She bought the finest clothing and personal items.

And Anna gambled. She liked the horses and would wager as much as fifty dollars a day. Because of her gambling habit and love of finer things, she was always in need of money. Early on, she was arrested for bouncing checks and was even looked at by authorities for suspicious fires.

Anna stacked lies upon lies as she enticed at least six older men into her web of poison for profit in order to keep the money flowing her way. She claimed to have been married to a doctor in Germany. She claimed to have been a nurse or a schoolteacher in the old country. She claimed whatever she needed to claim to relieve the elderly of their pensions and savings. Lonesome older men were gullible, easy prey. She would promise to marry them while bleeding out their bank accounts. Anna had no intentions of marrying any of them.

In 1930, in Buffalo, Anna married Phillip Hahn, a man close to her own age. It was a rocky marriage from the start, but it enabled her to bring her young son, Oscar, to the United States. She and her new husband started businesses together, but they always failed, one due to a suspicious fire.

Anna doted on her son and spent a great deal of time "caring" for elderly gentlemen. After a while, Phillip felt neglected and complained. His mother, Maggie, disapproved of her daughter-in-law and called her "high faluting." Unfortunately, Phillip and Maggie both suddenly became ill. They recovered, and Phillip later found that Anna had taken out a $10,000 double-indemnity insurance policy on his life. After that, he stayed away from home as much as possible.

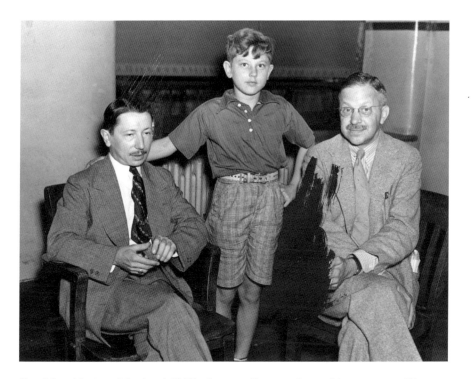

From left to right: Anna's husband, Phillip; her son, Oscar; and one of her attorneys, Hiram Bosinger. *Courtesy of Cleveland State University Library.*

Anna's first known victim to die was Ohio-born Albert "Bertie" Palmer, a retired railroad watchman. He was a perfect target for Anna. His wife, Lena, had died the previous year, so he was vulnerable. He also loved horseracing as much as Anna did. In December 1936, the two, with Oscar in tow, would play the ponies all day long. While Phillip was at work in the evening, Palmer would visit her house for dinner. By January 1937, she and Palmer were romantically involved—or at least he thought they were romantically involved. When she asked him for money, he gave it to her. At first, she wanted small amounts, but the amounts grew larger as their "relationship" progressed. One day, she asked for $2,000. He gave it to her, and she wrote out a promissory note to him but kept the note herself. After about a month, Palmer must have started to see through Anna, because he demanded either his money back or a commitment. She could not give him either, but she could cook dinners for him—dinners that would kill him.

After eating her food, he had severe stomach pains and began vomiting and having diarrhea. He went downhill fast, according to his sister, Anna

Horstmeyer, who lived downstairs from him. On March 26, 1937, Palmer died. The cause of death on his death certificate was influenza and heart disease. He was penniless at death. Anna had gotten all of his $5,000 savings.

Anna's next victim was Ernst Kohler, who owned a three-story house on Colerain Avenue. He lived on the top story by himself and rented out the rest of the rooms. Dr. Arthur Vos rented the first floor for his office. Vos was treating Kohler for throat cancer. Anna told everyone that Kohler had been friends with her father in Germany, and she convinced the old man and the doctor that she was a nurse, so she could take care of Kohler.

When Vos was not around, Anna snuck into his office and took advantage of his prescription pad. Within a week's period, she had filled seven prescriptions totaling more than 240 tablets of morphine. She also availed herself of his telephone to place bets with her bookies. When the druggist became suspicious, he wrote to the doctor, questioning the number of prescriptions. Anna intercepted the letter and forged a missive back to the druggist that said the prescriptions were proper.

Kohler died on May 6, 1937. Although he had been ill, his friends were suspicious; several called authorities. An autopsy was performed, but no poisons were found, because the coroner was not looking for poison. Anna, his caretaker, quickly had his body cremated. It seems as though Kohler had left everything to her. At least that is what his will said—the will that she produced. She took possession of his ashes as well as the house. Anna stored his ashes on the fireplace mantle of her inherited house. Oscar enjoyed looking at them from time to time.

Anna's schemes began to unravel after a trip she took to Colorado in July 1937. She wormed her way into the affections of an older German man named Johan Georg Obendoerfer, who spoke little English. A retiree with a small shoe repair shop in his home in Cincinnati, he had some savings.

They began seeing each other every day. Anna soon convinced the sixty-seven-year-old that they should marry, comingle their funds and move to Colorado to her nonexistent ranch, which she described in great detail. She also told him she had deposited some money in the bank for their joint account. The day before their trip, he went to the bank to withdraw his money from savings for their trip and to retrieve her money. He found she had no money in the account. When he asked her about it, she explained that she had put it in another savings and loan. In actuality, she had done no such thing. He must have wanted to believe her.

The night before their trip, Obendoerfer, probably giddy with the prospect of being with this younger, attractive blond, arrived at Anna's home with his

suitcase packed. She fixed him dinner, and he spent the night. By morning, when the taxi arrived, he was so ill he needed help getting into the vehicle. Anna had arranged for the cab to drive around to the alley in back of the house, probably so the neighbors would not see her guest. Before they left, she ran back into the house to leave a note for Phillip to tell him she was going on vacation.

Anna, Obendoerfer and Oscar boarded a train for Colorado. At a layover in Chicago, she checked Obendoerfer into a cheap hotel room then secured a much nicer room for her son and herself—with the old man's money, no doubt. From there, they traveled on to Denver, where Anna checked them into the Oxford Hotel. The bellman there noticed how ill Obendoerfer was and voiced his concern. Anna did not want anyone sticking his nose into her business, so she checked them out of the Oxford and into the Midland Hotel the next day. In polite conversation, she told the proprietor of that hotel that she had met Obendoerfer on the train in Chicago.

Obendoerfer's illness grew worse. He suffered from terrific stomach cramps and had an insatiable need for water. While he lay in bed, writhing in pain, Anna took pen in hand and wrote a letter on hotel stationery to Obendoerfer's bank asking for $1,000. The letter stated that he was going to stay in Colorado with his sister-in-law. She signed it with her maiden name. When the money did not arrive, she wired the bank—this time forging Obendoerfer's signature.

The Midland hotel clerk could see that the old man was gravely ill and insisted he go to the hospital. Anna assured him, "I just gave him a big dose of croton oil [a powerful purgative]. He'll be all right." She was also feeding him watermelon laced with arsenic. Croton oil was not one of the poisons coroners looked for during an autopsy. Anna used it to clear the arsenic from her victims' stomachs. She may not have known that arsenic could still be found in the organs.

When the check arrived from Obendoerfer's bank, Anna promptly took it to the nearest bank. The cashier there would not accept the check unless Obendoerfer endorsed it in front of a bank employee. She told the cashier that Obendoerfer was too far away to come to the bank (he was actually right down the street on his deathbed), so she asked that it be sent on to Colorado Springs, where they were going next.

On the train from Denver to Colorado Springs, the old man begged for water. Oscar later told authorities he gave him at least eighteen glasses of water. With great difficulty, Anna got the sick man off the train in Colorado Springs and installed him into a room at the Park Hotel, owned by Pell and

Rosie Turner. She registered him with a Chicago address. Anna and her son took a room for themselves, left the dying man alone and went out to dinner and to see the town.

Later, when Mrs. Turner inquired about Obendoerfer, Anna said he was just an old man she met on the train from Denver. Because he was so ill, she felt sorry for him and was trying to take care of him.

After a day or so, the Turners grew more and more concerned. They finally insisted that Obendoerfer be taken to the hospital. Anna relented and called a cab. She had taken every last penny he had with him, so the hospital took him in as a charity case. He was beyond being able to speak for himself, and even if he could, it would have been in German, so no one would have been able to understand him. Doctors at the hospital asked Anna about his identity, but she claimed she did not know him.

Georg Obendoerfer died on August 1, 1937. That same day, Anna sent a postcard to her brother, telling him what a wonderful time she and her husband were having on their vacation.

Even the undertaker asked her who the old man was. "He was just an old German I met on the train," she said. Obendoerfer was buried in Colorado, far away from his home and family.

Still staying at the Park Hotel, Anna wandered the halls one day and noticed the door to the Turners' private rooms was ajar. Glancing up and down the hall, she assumed it was safe to slip into the room. There on the dresser were two diamond rings. She snatched them up and secreted them in her pocket.

Rosie Turner walked in on her. "What are you doing? You don't belong in here. Get out." At the time, she did not realize her rings had just been stolen.

Anna was anxious to leave the city after that. She packed hers and Oscar's bags, then jammed Obendoerfer's belongings into his suitcase along with two salt shakers, one full and one nearly empty. They contained arsenic, not salt.

Anna and Oscar headed for the train station. Along the way, they passed a pawnshop, where she unloaded the diamond rings for a mere $7.50. They were valued at over $300.00. When she and her son arrived at the Colorado Springs train depot, she checked Obendoerfer's bag, figuring it would never be seen again. After she and her son were seated on the train headed back to Cincinnati, she told him if he was ever asked about the rings to say they had found them on the street.

When Rosie Turner realized her diamond rings were gone, she called the police. Colorado Springs detective Irvin B. Bruce acted quickly, swearing out

Oscar Hahn, Anna's son. *Courtesy of Cleveland State University Library.*

a warrant for grand larceny for the theft of the jewelry. He sent a telegram to the Cincinnati police asking that Anna be taken into custody. Bruce also wanted to talk to Anna about Georg Obendoerfer. The old man had died with no identification, but by using the label in Obendoerfer's clothing, Bruce was able to track him to a Cincinnati tailor.

Anna and her son had just gotten home from Colorado when Cincinnati police came knocking on her Colerain Avenue door.

Captain Patrick H. Hayes was Cincinnati's acting chief of detectives. He was a big man who took advantage of his size and his fists when it came to noncompliant suspects. Once Anna was seated across from him, he thought she was pretty. She was a small woman, so he decided to use his stature to intimidate her. He soon found that was not going to work. He did not know much about her at the time, but experience told him there was something sinister behind the attractive exterior.

Hayes questioned Anna about her trip out West, asking her who was with her. Only her son—the lie came easily.

Hayes showed her a photo of Obendoerfer that Bruce sent him. Anna became combative at the sight of the picture and started to build more lies. She claimed to have made his acquaintance in Chicago, and they sat together on the train to Denver. She felt sorry for him. "He was old and all alone." She said he went along with her and her son when they traveled to Colorado Springs. They checked into the same hotel. She looked after him. "I'm kind-hearted that way," she said.

Franklin wrote that Cincinnati homicide detective George W. Schattle happened to overhear the questioning. It piqued his interest. When he found out Anna's last name, he knew that she had been involved in a case that he and his detectives had been working on with little success. It was the suspicious death of another old man, Jacob Wagner, in June.

Schattle became involved in investigating Wagner's death after the dead man's friends contacted the police several times and finally the prosecutor's office. They were suspicious of a young blond whom Wagner had been seeing. Not long after this woman came into Wagner's life, he quickly became ill and died.

Cincinnati authorities concentrated on Wagner's death. They learned through Wagner's relatives that Anna had tried to get $1,000 from his bank account. That was enough to exhume the body.

Anna had carried a white, crocheted purse with her to the police station. It was the same one she carried in Colorado. Hayes and Schattle looked through it and found a handwritten note stating, "Feel sorry for Mrs. Hahn. She is not to blame." Anna told them Wagner had written it. The problem was, Wagner could not write in English, only German. At trial, prosecutor Outcalt would present evidence that the purse contained traces of croton oil.

As Outcalt began putting his case together, he spoke with five of Wagner's neighbors. After his opening statement, these five neighbors—all women—

would be some of the first witnesses. Each testified that Anna had come into their building and knocked on random doors, looking for "an old man who lived alone." She did not mention his name. Neighbor Nannie Werks told her an older man lived down the hall and his name was Wagner. Anna seized on the name and said, "Yes, he is my uncle and I have a letter for him. It's from relatives in Germany. He's come into some money." She went to his door and knocked. No one answered, so she slipped a note under his door.

Anna met Jacob Wagner a few days later, according to the testimony of another neighbor. Anna was the only woman the witness ever saw in his apartment. Wagner spoke poor English, but the neighbors understood his accent well enough to know he was calling her his "girl." He made it clear that she was not his niece.

Things went well until Wagner's bankbook, with a balance of more than $4,500, came up missing. He reported the loss to the bank. Previously, Anna had given him her two bankbooks to hold on to. One had a balance of $3, but the other had several typewritten deposits that added up to $15,000. Suspicious, he took them with him to the bank. The clerk thought they were forged and advised Wagner to swear out a warrant for her arrest.

When he accused Anna of stealing his savings book in front of people at a neighborhood restaurant, she became indignant. She bid him to go back to his apartment with her so they could search for it. Conveniently, she "found" his bankbook. Anna wrote a note to the bank saying the book had been misplaced and had been found under some papers. She forged Jacob Wagner's signature.

The *Cincinnati Enquirer* reported that two neighbor women, Elizabeth Colby and her daughter Josephine Martin, told the court they had seen Anna in Wagner's room on Sunday, May 30, 1937. Their apartment faced Wagner's, and they could see right into one of the rooms. They witnessed Anna pouring something into a glass multiple times and taking it across the room. Two days later, Wagner was in acute pain. He started to vomit. He had diarrhea and began to pass blood.

The next witness to take the stand was a neighborhood doctor, James H. Clift. He told the court that Anna called herself Wagner's niece. "Do you think he is going to die?" Anna asked. Clift told her he did not think so, but he thought the sick man should go to the hospital. She claimed to have been a nurse in the "old country." She also told him she was a doctor's widow. Clift examined Wagner and prescribed paregoric.

Wagner's strength was dwindling, but he insisted on another doctor, one that the neighborhood druggist knew. Anna followed his request and fetched

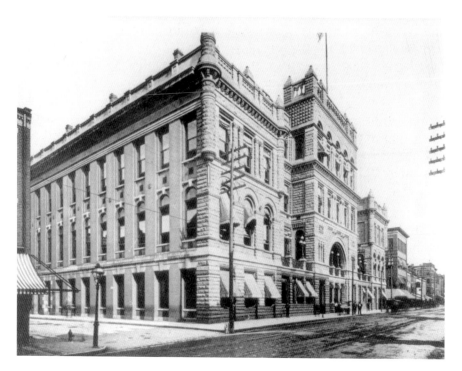

Hamilton County Courthouse. *Courtesy of the Public Library of Cincinnati and Hamilton County.*

Dr. Richard Marnell. After examining the patient, Marnell ordered him to the hospital.

Anna complied and rode in the ambulance with Wagner. She claimed that on the way to the hospital the sick man gave her a check for $1,000 to "take care of things" for him. It was written in pencil. The bank refused to honor it, so she took another check and forged it.

Another neighbor, Ida Martin, told the court that Anna came to her the day before Wagner died and told her to take whatever she wanted from Wagner's room. "I sent the old man to the hospital. You know he is my uncle," Mrs. Martin repeated for the court. "Mrs. Hahn said he wasn't coming back." Jacob Wagner died on June 3. 1937.

Wagner's friends said he had never talked about Anna until just a few days before he died. One recalled him saying, "Well, I kissed her but she made me sign over my money."

Anna also was under indictment for the death of sixty-seven-year-old George Gsellman, a railroad retiree. According to Franklin, on July

6, 1937, Gsellman's friend August Schultz found him dead in his attic apartment on Elm Street. He was lying in bed, nude except for his slippers. A nearby table was set for two, and there was a pot of meat and gravy on the stove. The city chemist, Dr. Otto P. Behrer, examined the congealing food and found enough arsenic in it to kill several men. No one came forward to claim Gsellman's body, so it was taken to the morgue, where it stayed for several days. The Anatomical Society of the School of Medicine took the body but, apparently having no use for it, returned it. Gsellman was lowered into his grave on August 12 but not covered in dirt yet when authorities ordered it to be exhumed. It was the same day Jacob Wagner's body was exhumed.

Gsellman was not well-heeled, but he did enjoy nightlife, the ladies and nice clothes. He had been spurned by one lady but then met another. He told friends all about her. She was a young blond. He boasted that they were going to get married and go to California. He had even set the wedding date: July 6.

Anna denied knowing Gsellman, but Schultz told investigators that he had seen Anna at Gsellman's apartment many times. Schultz and his wife saw Anna taking the victim to the bathroom on the second floor the day before he died. He "seemed very weak and was holding onto the banister for support. He was breathing hard."

According to *Cincinnati Enquirer* reporter Joseph Garrestson Jr., *Times Star* reporter Charles Ludwig and photographer Peter Koch gained entrance to Gsellman's room a month after the victim died. Koch found a streetcar ticket under a board on the table with the message "Go home. I'll be there." Handwriting experts confirmed it was Anna's handwriting. She and Gsellman lived on the same streetcar line.

The most dramatic moment in the trial came when George E. Heis, sixty-two, was wheeled into the courtroom. An eerie silence fell over the jury and spectators as he testified from his wheelchair. He appeared to have little muscular control over his limbs. His spider-like fingers crawled across his lap, constantly clutching at something invisible. His frail, skinny legs crossed and uncrossed repeatedly. Although he was only a few feet away from Anna, he never looked up at her.

He described how he had been a hardworking, healthy coal dealer until a few months after he met Anna Marie Hahn. He told the court that he had known Phillip Hahn for some time but only crossed paths with Anna for the first time in June 1936. She began to woo him right away. During one of her visits she gave him a package that she claimed contained Hungarian

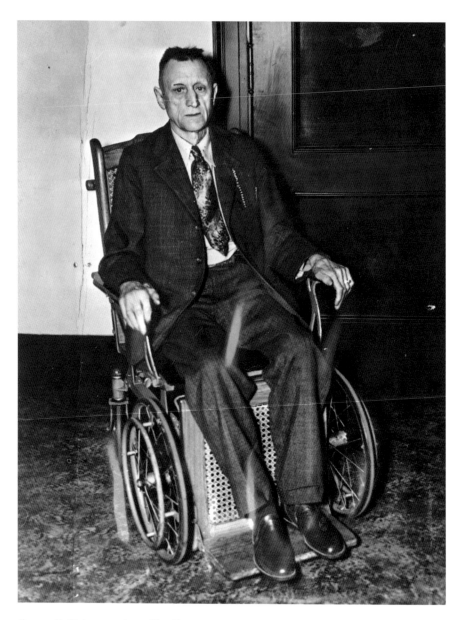

George E. Heis was poisoned but lived to testify against Anna Marie Hahn. *Courtesy of Cleveland State University Library.*

bonds and asked him to put it in his safe. She told him she was divorcing her husband and did not want him to get a hold of the bonds.

Heis proceeded to tell the court how she swindled him out of $200 here and $200 there for her "divorce" and "inheritance taxes." Sometimes she asked for smaller amounts. He always gave it to her. She asked for and got money to buy a "rising stock." Then there was a house and farm she wanted to buy. He gave her money for a down payment. Next, she needed money for upkeep on the house. She needed money for taxes on the farm. She promised to put the house in his name. She promised to turn the stock over to him. She promised to put her inherited trust fund in his name. None of this was true. There was no stock. There was no farm, so there were no taxes or upkeep. There was no inheritance.

Heis had taken a total of $2,000 from Consolidated Coal Company, where he worked, to give to Anna. In time, the company wanted its money back. When Heis broached her on the subject and asked her to pay him back, she became defensive. She did not pay him back. Instead, she began to cook for him.

He started to get really sick with stomach cramps and diarrhea. He put two and two together during one meal when he tasted something sweet in the spinach. Every time she brought him food, he would get worse. He told the court that he held out his shaky hands for her to see and said "You did this to me." Then he "ran her out."

Heis's physician, George C. Altemeier, followed him to the stand and testified that he diagnosed his patient with "arsenical poisoning." He said Heis had been bedridden for a year.

After ninety-six witnesses and one hundred exhibits, Outcalt gave his closing argument. According to the *Plain Dealer*, he called Anna "a sweet-voiced, kindly faced blond Borgia."

He proclaimed, "Anna Hahn is the only one in God's world who had the heart for such murders. She sits there with her Madonna face and her soft voice, but they hide a ruthless, passionless purpose, the like of which this state never knew before." He ended by saying, "A woman who has killed so many men there is not a human being like her on the face of the earth." Outcalt thundered: "This was a brutal murder, conceived only for the purpose of obtaining money. I ask you to return a verdict of guilty and to assess the supreme penalty."

Defense counselors Joseph Hoodin and Hiram Bolsinger tried to counter Outcalt's closing argument by telling the jury that Anna was not an angel and admitting she had forged checks. "But there's a difference between

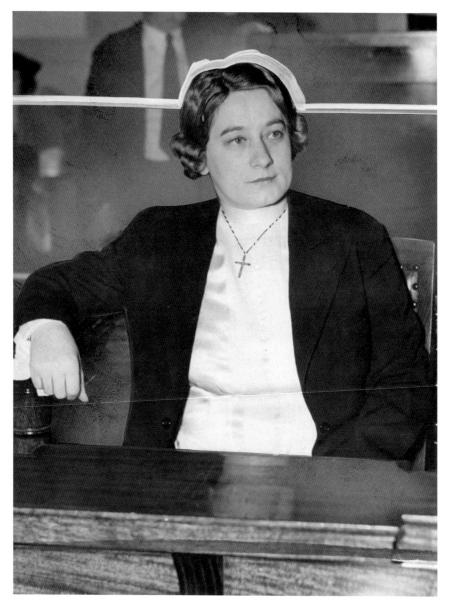

Above: Anna Marie Hahn listened as witnesses testified against her. *Courtesy of Cleveland State University Library.*

Opposite, top and middle: Front and back of the drinking cup Anna Marie Hahn used in prison. *Courtesy of Ohio History Connection.*

Opposite, bottom: Anna Marie Hahn's rosary. *Courtesy of Ohio History Connection.*

stealing and running around with men and first-degree murder."

The jury spent two and a half hours deliberating. It came back with a verdict of guilty and no recommendation of mercy. It was a death sentence. Anna Marie Hahn would go to the chair.

Five days before Anna was to die in the electric chair, United Press International reported that thirteen-year-old Oscar went with her attorneys, Hoodin and Bolsinger, to appear before Governor Martin L. Davey's secretary, Daniel S. Earhart, to plead for his mother's life.

No. 214, Mrs. Anna Marie Hahn of Hamilton County. Legally Electrocuted December 7th, 1938, for the Murder of Mr. Jacob Wagner, at Cincinnati, Ohio.

Anna Marie Hahn was executed for the murder of Jacob Wagner. *Courtesy of Ohio History Connection.*

"I don't think she ever did that," Oscar was reported to have said. "She has been a good mother. I don't want her to die. I don't think there ever could be a mother as good as she. Nobody can ever take her place."

The Hamilton County prosecutor, Carl Rich, who was sitting in on the hearing, was recorded to have said, "Oscar is a fine boy, but his mother is a mass murderer in every respect. She does not deserve clemency."

Hoodin and Bolsinger maintained that the newspapers were prejudiced against Anna. They further accused Hamilton County prosecutor Dudley Miller Outcalt of using her case for political gain. The pleas fell on deaf ears.

A few days before her execution, Anna wrote out a confession. Unable to claim responsibility for her murderous deeds, she wrote, "It was another mind that made me do these things." The confession ran in its entirety in the *Cincinnati Enquirer* on December 19 and 20, 1938. In part, she wrote, "I never had felt unkind to anyone and always tried to help those that were in trouble." A handwritten excerpt ran in the *Pittsburgh Post-Gazette*. It seemed as though she put part of the blame on being rejected by Dr. Max Matchek, the married man she claimed was Oscar's father.

Anna Marie Hahn was executed on December 7, 1938. She is buried in Mount Calvary Cemetery in Columbus. Five murders were attributed to her, and at least three others were suspected.

SOURCES

Books and Magazines

Franklin, Diana Britt. *The Good-bye Door: The Incredible True Story of America's First Female Serial Killer to Die in the Electric Chair.* Kent, OH: Kent State University Press, 2006.

Gillespie, L. Kay. *Executed Women of the 20th and 21st Centuries.* Lanham, MD: University Press of America, 2009.

Hunter, Bob. *Historical Guidebook of Old Columbus: Finding the Past in the Present in Ohio's Capital City.* Athens: Ohio University Press, 2012.

Jadwisiak, Casimir "Ki." *An Immigrant Family History.* Sandusky, OH: Loris Printing, 2014.

Lanning, Jay Ford. *Ohio Criminal Law and Practice: A Practical Treatise, with Directions and Forms.* Norwalk, OH: Lanning Printing, 1901.

Lape, Debra. *Looking for Lizzie—The True Story of an Ohio Madam, Her Sporting Life and Hidden Legacy.* Createspace, 2014.

Lucas, Richard. *Axis Sally: The American Voice of Nazi Germany.* Havertown, PA: Casemate, 2010.

Martin, William T. *History of Franklin County: A Collection of Reminiscences of the Early Settlement of the County.* Columbus, OH: Follett, Foster & Co., 1858.

McNutt, Randy, and Cheryl Bauer McNutt. "Mildred Gillars, Traitor and Teacher." In *Unforgettable Ohioans: Thirteen Mavericks Who Made History on Their Own Terms.* Kent, OH: Black Squirrel Books, 2015.

O'Shea, Kathleen A. *Women and the Death Penalty in the United States.* Westport, CT: Greenwood Publishing, 1999.

Quackenbush, Jannette Rae, and Patrick Quackenbush. *Ohio Ghost Hunter Guide III: A Ghost Hunter's Guide to Ohio.* Creola, OH: 21 Crows Dusk to Dawn Publishing, 2012.

Sheaffer, John C. "The First Lady Sheriff, Maude Collins of Vinton County." *Buckeye Hill Country: A Journal of Regional History.* Vol. 1. Rio Grande, OH: University of Rio Grande, Spring 1996.

Shipman, Marlin. *The Penalty Is Death: U.S. Newspaper Coverage of Women's Execution.* Columbia: University of Missouri Press, 2002.

St. Joseph Gazette. "Unwanted Woman Back to Jail Where She Has Spent 37 Years." February 3, 1962, 11. Retrieved from https://news.google.com/newspapers.

Streib, Victor L. *The Fairer Death: Executing Women in Ohio.* Athens: Ohio University Press, 2006.

Tribe, Deanna L. Images of America: *Vinton County.* Charleston, SC: Arcadia Publishing, 2015.

Newspapers

Akron (OH) Beacon Journal
Akron (OH) Daily Democrat
Akron (OH) Press
Arizona Republic (Phoenix)
Battle Creek (MI) Enquirer
Canton (OH) Repository
Cincinnati (OH) Commercial Tribune
Cincinnati (OH) Enquirer
Cincinnati (OH) Post
Circleville (OH) Herald
Charleston (WV) Gazette
Chicago Sun Times
Chillicothe (OH) Gazette
Clermont (OH) Sun
Cleveland (OH) Leader
Columbus (OH) Dispatch
Columbus (OH) Evening Dispatch
Coshocton (OH) Tribune
Defiance (OH) Daily Crescent
Delphos (OH) Daily Herald

Delphos (OH) Weekly Herald
Democratic Northwest (Napolian, OH)
Detroit Free Press
East Liverpool (OH) Review
Elyria (OH) Chronicle Telegram
Elyria (OH) Evening Telegram
Evening Independent (Massillon, OH)
Evening Star (Washington, D.C.)
Findlay (OH) Morning Republican
Hamilton (OH) Daily Democrat
Journal News (Hamilton, OH)
Lima (OH) Daily Democratic Times
Marion (OH) Star
Marysville (OH) Evening Tribune
McArthur (OH) Democrat Enquirer
Medina (OH) County Gazette
Medina (OH) Sentinel
Morning Advocate (Baton Rouge, LA)
Newark (OH) Advocate
New Messenger (Fremont, OH)
News Herald (Port Clinton, OH)
News Journal (Mansfield, OH)
New York Times
Ohio State Journal
Ohio Statesman
Oregonian (Portland, OR)
Ottawa County (OH) News
Ottawa Free Trader (Ottawa, IL)
Piqua (OH) Daily Call
Pittsburgh (PA) Post-Gazette
Plain Dealer (Cleveland, OH)
Port Clinton (OH) Daily News
Portsmouth (OH) Daily Times
Richmond (VA) Times Dispatch
Sandusky (OH) Daily Register
Sandusky(OH) Journal
Star Beacon (Ashtabula, OH)
Steubenville (OH) Herald
Summit County Beacon (Akron, OH)

Times Herald (Orlean, NY)
Times Recorder (Zanesville, OH)
Toledo (OH) Blade
Xenia (OH) Daily Gazette
Zanesville (OH) Signal
Zanesville (OH) Times Recorder

Court Records, Websites and Other Sources

Albrecht, Brian. "Ohio-Bred Axis Sally's Journey from Nazi Propagandist to Federal Pen to Columbus Convent." *Plain Dealer*, May 22, 2011. www.cleveland.com/books/index.ssf/2011/05/axis_sally_ohio-born_mildred_g.html.

Ancestry.com. www.ancestry.com.

Application for Probate of Will of Hawkins Dean. Probate Court. Clermont County, Ohio. Doc. 39, 165. Filed August 29, 1952.

Bovsun, Mara. "The Poison Widow of Hardscrabble." *New York Daily News*, October 7, 2007. http://articles.nydailynews.com.

Certificate of Death for Kathleen Myers, May 4, 1941, No. 5053. West Virginia Department of Health.

Certificate of Marriage, H. Dean to Dovie B. Myers, April 13, 1952. Probate Court, Clermont County, Ohio.

Dean, Hawkins. Last Will and Testament of Hawkins Dean. April 12, 1952. Probate Court, Clermont County, Ohio.

Death—Additional Information for Hawkins Dean, August 21, 1952. File No. 49628, State of Ohio Department of Health.

Death Certificate for William Taylor, August 15, 1890, File No. 454356. Cincinnati (Ohio) Health Department, University of Cincinnati Libraries.

Divorce of Carl G. Myers and Dovie B. Myers, April 11, 1952. Case No. 24154. Clermont County, Ohio.

Feather, Carl E. "Guilty of Treason!" *Star Beacon*, November 25, 2012. www.starbeacon.com/news/local_news/guilty-of-treason/article.

———. "New Jersey Author Writes Biography of Conneaut's Axis Sally." *Star Beacon*, October 9, 2010. www.starbeacon.com/community/new-jersey-author-writes-biography-of+conneaut-s- axis-sally/article.

Find a Grave. www.findagrave.com.

Good, Meaghan. "1844: Hester Foster and William Young Graham." Executed Today. February 8, 2014. www.executedtoday.com.

Gribben, Mark. "Another One Beats the Chair." *Malefactor's Register*. https://malefactorsregister.com/wp/another-one-beats-the-chair.

Harper, Dale. "Mildred Elizabeth Sisk: American-Born Axis Sally." HistoryNet, June 6, 2006. www.historynet.com/mildred-elizabeth-sisk-american-born-axis-sally.htm.

Hebert, Lou. "Once Notorious Madam Dies in Quiet Obscurity." Toledo Gazette. http://toledogazette.wordpress.com/2012/01/27.

———. "Round the Clock Gone, but Memories and Questions Linger." *The Press*, November 7, 2014.

Jon Husted, Ohio Secretary. Business Filing Portal. https://www5.sos.state.oh.us/ords/f?p=100:2:::NO:RP::.

"Maine's Mildred Gillars Wanted Fame and She Got it." New England Historical Society, 2017. www.newenglandhistoricalsociety.com/maines-mildred-gillars-wanted-fame-and-she-got-it.

Marriage Records. Raymond K. Sherry to Rosie Shallo, October 28, 1929. Application No. 250279, Cuyahoga County, Ohio.

Miscellany. www.arc.id.au/Calendar.html.

Register of Marriage, Carl G. Myers and Dovie Blanche Smarr, August 7, 1918. Clendenin, West Virginia, GS Film No. 521711, Digital Folder No. 4226399, Image No. 00075.

State of Ohio v. Carter. 25 W.L.B. 17 (C.P. 1890).

State of Ohio v. Palmer. Docket 4, case no. 2477, Vinton County Common Pleas Ct. (1927).

State of Ohio v. Stout. Docket 4, case no. 2465, Vinton County Common Pleas Ct. (1927).

Stevenson, Matt. "The Anatomy of a Lie: Exploring the Propaganda of Axis Sally." *Magnificat: A Journal of Undergraduate Nonfiction*. Arlington, VA. Marymount University, April 2007.

St. Joseph Gazette. "Unwanted Woman Back to Jail Where She Has Spent 37 Years." February 3, 1962, 11. https://news.google.com/newspapers.

Taylor, Blaine. "Mildred Gillars (A.k.a. 'Axis Sally') in WWII." Warfare History Network, March 21, 2016. warfarehistorynetwork.com/daily/wwii/mildred-gillars-a-k-a-axis-sally-in-wwii/print.

"Thriller Thursday: The Trial of Tilby Smith." Adventures of an Untameable Genealogist. March 12, 2015. https://untameablegenealogy.wordpress.com/category/ashtabula.

Turzillo, Jane Ann. "Dago Rose." Dark Hearted Women. http://darkheartedwomen.wordpress.com/2015/11.

United States Census, 1930, 1940.

Van Dyne, Corp. Edward. "No Other Gal Like Axis Sal." *Saturday Evening Post*, January 15, 1944.

YouTube. "Almanac. Axis Sally, A Voice from the Past." https://www.youtube.com/watch?v=_7gqelca2cw&t=44s

————. "Berlin Calling—Axis Sally." https://www.youtube.com/watch?v=49FV-njfp5s

INDEX

ABOUT THE AUTHOR

*J*ane Ann Turzillo is the Agatha-nominated author of *Unsolved Murders & Disappearances in Northeast Ohio* and the National Federation of Press Women's award winner for *Ohio Train Disasters*. *Wicked Women of Ohio* is her seventh book for The History Press and Arcadia Publishing. A full-time author and speaker, she concentrates on true crime and history. As one of the original owners of a large weekly newspaper, she covered police and fire news. She is a graduate of The University of Akron with degrees in criminal justice technology and mass-media communication. She is a member of Sisters in Crime, Mystery Writers of America and the National Federation of Press Women. Visit her website at www.janeannturzillo.com and read her blog at http://darkheartedwomen.wordpress.com.

Visit us at
www.historypress.com